LEGENDARY L

—— OF ——

GREATER UTICA
NEW YORK

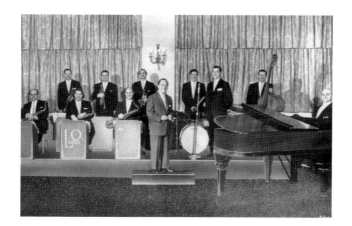

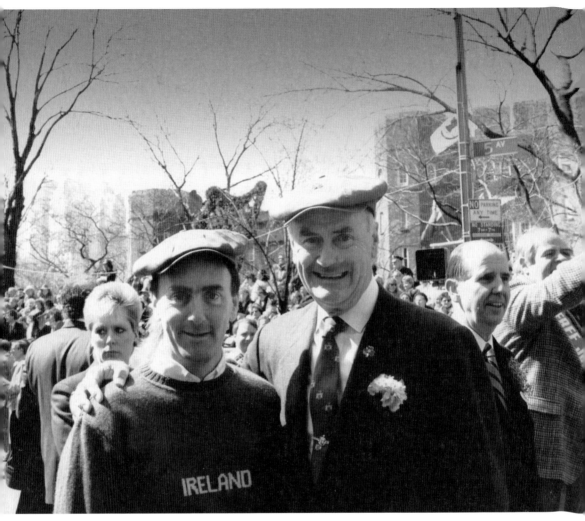

Jerry Donovan and State Senator James Donovan
Jerry Donovan is alongside his father, state senator James Donovan, at New York's St. Patrick's Day Parade. James Donovan served the region for many years in Albany and is the namesake of several local institutions. (Courtesy of Jerry Donovan.)

Page 1: The Lawrence Luizzi Band
Featuring Pat Santacroce (see page 101) on vocals, the Lawrence Luizzi Band played countless venues during the 1950s. The longtime house band at the Hotel Hamilton—Utica's largest hotel at the time—Luizzi's group performed a variety of American musical standards. "When I arrived in Utica in 1949, I couldn't believe the quality of music going on in the area," Santacroce recalls, "for a musician like me, it was as if I landed in paradise." (Courtesy Pat Santacroce.)

LEGENDARY LOCALS
—— OF ——

GREATER UTICA
NEW YORK

JAMES L. DAVIS

LEGENDARY
LOCALS

Legendary Locals is an imprint of Arcadia Publishing
Charleston, South Carolina

Printed in the United States of America

Library of Congress Control Number: 2013930312

For all general information, please contact Arcadia Publishing:
Telephone 843-853-2070
Fax 843-853-0044
E-mail sales@arcadiapublishing.com
For customer service and orders:
Toll-Free 1-888-313-2665

Visit us on the Internet at www.arcadiapublishing.com

Dedication
To Joseph P. Bottini, who gave me my first teaching job and who has loved this region as much as anyone ever has.

On the Front Cover: Clockwise from top left:
F.X. Matt II, Saranac Beer brewer (Courtesy of the Matt Brewery; see page 58), Donna Donovan, newspaper publisher (Courtesy Utica Observer-Dispatch; see page 88), Vice President James Schoolcraft Sherman (Courtesy Library of Congress; see page 25), Thomas Proctor, business leader and philanthropist (Courtesy Oneida County Historical Society; see page 24), George Cogar, computer pioneer (Courtesy Cherylynn Tallman; see page 54), Carmen Basilio, boxing champion (Courtesy Claudia Dugan; see page 105), F. Eugene "Gene" Romano, industrialist and philanthropist (Courtesy Pacemaker Steel; see page 40), Rufus J. "Rufie" Elefante, political leader (Courtesy Oneida Country Historical Society; see page 33), David Mathis, education and civic leader (Courtesy David Mathis; see page 90).

On the Back Cover: From left to right:
Jason (left) and Dean (right) Nole, noted chefs (Courtesy Dean Nole; see pages 62–63); Robert Esche, professional hockey player and entrepreneur (see page 55).

CONTENTS

ACKNOWLEDGMENTS

Joseph P. Bottini, with whom I wrote Then & Now: *Utica*, was the best research assistant one could ask for in completing this book. He tracked down many interviews and images and provided his own historical insight, which greatly informed my thinking. Ryan Orilio essentially fulfilled the work of art director for the book, culling, organizing, and sweetening my selected images and contributing many of his own photographic gems. It was great to have Joe and Ryan along, as the book would not have been completed without them. Of course, many thanks go to my editor, Erin Vosgien, at Arcadia Publishing.

Prof. Eugene Paul Nassar provided me with some early and treasured encouragement and also read some early drafts that resulted in crucial feedback. Dean Alexander Thomas of the State University of New York (SUNY) at Oneonta was an early correspondent during my initial research, and his expertise helped me narrow down some of the themes for this book.

Many other individuals were crucial in assisting my work, several of them legendary locals. Carl Saparito and Brian Howard of the Oneida County Historical Society (OCHS) helped me research and select almost two dozen of the historical images herein. John Zogby, who graciously agreed to an interview immediately, gave the thoughtful insights that provided the book's initial momentum; Robert Esche was crucial to keeping the research momentum going at the critical mid-point. Robert Cimbalo and the DiSpirito family were trusted guides as I made my first foray in art research. My appreciation also goes to Josef Orosz; Christian Goodwillie; Denise Alexandra; Meghan Fraser; Ian Foxton; Kristina Swan Orilio; and Ron Johns at the *Observer-Dispatch*. As always, my fabulous wife, Karen (see page 39), made sure I stayed on track as the book finally took shape.

Thank you to all of the legendary locals and their families, who were so gracious with their time and so enthusiastic about this book. Most of the images contained within this volume were provided by the subjects themselves or their families. Unless otherwise attributed, all quotes were provided by the legends themselves for this book.

Any mistakes are my own. I hope that a future author will pick up where I left off, as many notable Uticans do not, regrettably, appear in the following pages.

INTRODUCTION

Utica is *real*. Its neighborhoods and the communities that surround them are filled with people whose passion for family, food, faith, and civic engagement are exemplars of the true American experience. Utica is without pretense. Lives devoted to the arts, business, politics, sports, and scholarship have found their start—and oftentimes, their purpose—in Greater Utica. The region's most-celebrated leaders and innovators have been prime actors or integral players at turning points in American history. Those who look to reclaim Utica's birthright as an essential American city speak to the values of the people living here as well as to the quintessential American virtue of resilience and its handmaiden, self-improvement.

In examining the lives of local luminaries from the 19th century, one is struck by a sense of optimism, rugged individualism, and flexibility. Many of the people from the Greater Utica area who would one day become local legends were often willing to take calculated risks and give anything a shot, whether as land speculators, industrialists, or artists. If Utica possessed any pretense at all in its early days, as assuming itself to be the very heart of the Empire State, its assumptions were borne out by the accomplishments of the Butterfields, Williamses, Faxtons, and Proctors. A modern reader will no doubt find it striking that it was not atypical for a Utica native such as the artist Arthur B. Davies—a giant of early-20th-century art, though rarely celebrated these days—to leave Utica in young adulthood because their families wanted to try their fortunes in a less established town: Chicago. To a person living in Utica at the mid-20th century, it would not have seemed unreasonable to believe that Greater Utica would continue to prosper. Personalities as disparate as brewer Walter Matt and political-machine boss Rufie Elefante built coalitions at mid-century to help the city yet again redefine itself as economically and culturally vibrant.

That tens of thousands left Utica in the postwar years for other communities speaks more to the larger forces of global economics than how many people actually felt about living in this small, manageable, and diverse city. The fact that so many Utica-area natives have moved miles away but continue to read the online edition of the local paper may only be explained as a variant of what Florentines call *nostalgia del cupolone*, referring to a longing to be back home in the shadow of their city's famous landmark, the Duomo. Unfortunately, as demonstrated in *Utica: A City Worth Saving* (1976) and *Then & Now: Utica* (2007), many of Utica's most-celebrated landmarks had been lost, and half the city removed, in the name of urban renewal. The nostalgia yet remains. Just as in much larger urban areas, like Greater Detroit and Buffalo, people have not given up on Utica.

Sociologist Alexander Thomas has studied Utica and communities like it for the past 15 years. His 2003 work *In Gotham's Shadow* describes Utica as a city stinging from a loss of stature during the previous 60 years, a decline only exacerbated by economic globalization and Utica's inability to compete with larger cities for capital investment. As a result, Utica went from being a vibrant American city to being perceived as a small town in the public's consciousness, though the city's population as of 2010 was more than 62,000. A decade after his initial study, Thomas today suggests, "Utica must now come to terms about what it means to be a mature economy . . . This may seem too insurmountable a challenge, but it is not one that is alien to Utica." Though the economic booms that the city experienced in the past are unlikely to occur again, Utica may be able to position itself for moderate growth as its population and municipal budgets stabilize; it is a vantage point the city has recognized before—particularly when its dominance in the textile industry eroded—and one that Uticans hoping to regain their home's past luster will need to start from again.

Many of the profiles that follow share the stories of contemporary Uticans who thrive despite their hometown's challenges. This is true in the city itself and in the towns, such as New Hartford and Whitesboro, that absorbed much of its population in the postwar years. Nationally renowned professionals like political

pollster John Zogby still call Utica home. Zogby and many others have discovered that there is much to be derived from a community that is steeped in history, diversity, and innovation. Sports stars such as Robert Esche have found new purpose outside the arena of play by investing in new local businesses. Volunteers such as Margaret Ford show why this town, though now considered a small town by modern American standards, may have the biggest heart around. Indeed, the ongoing success of the Boilermaker Road Race and the Great American Heart Run & Walk are fueled by the passion of volunteers. It must also be said that Utica continues to be a beacon for refugees throughout the world, and it is an example of religious and ethnic peaceful coexistence that escapes many more-celebrated cities.

Utica is a "fighting town" that has gone through several bouts of exhilarating highs and withering lows that other industrial cities have likewise survived, the sort of misfortunes that even the most robust modern cities could not escape during the Great Recession. Greater Utica just needs, as Fr. Paul Drobin aptly suggests, "less Exodus and more Genesis." In terms of the art world, perhaps it also needs less Arthur B. Davieses and more Henry DiSpiritos, the celebrated artist of another generation who resisted the desire to fill the galleries of major metropolitan museums and instead chose to fill a sculpture garden behind his East Utica home. His family, his friends—his purposeful life—after all, were here. *Legendary Locals of Greater Utica* hopes, if anything, to show the next Proctor (or DiSpirito, Romano, Cogar, or Donovan) that they stand on the shoulders of local giants who would not mind seeing this place—whether a big city or small town—regain its swagger.

CHAPTER ONE

Cornerstones and Benefactors

The cornerstone personalities of the Greater Utica area are the people who have laid the groundwork for life in the region. These legendary locals themselves laid the cornerstones for the area's most durable institutions; some set the stage for the growth of the region, while others nurtured Greater Utica during its most prosperous times. They established the public places that have become second homes for so many. Greater Utica has come to depend on the contributions of Theodore Faxton, the Matt Family, and the triumvirate of the Munson-Williams-Proctor extended families, not only for establishing the region's essential institutions but also for providing models to emulate. Several of them, such as Roscoe Conkling, Horatio Seymour, and Francis Kernan, directed the course of the nation's history during a time of significant social and political change.

Very few of these legends held office, though some are immortalized in bronze to signify their contributions. Some run bakeries and stores that have been operated by several generations of the same family, while others, like Chief Skenandoah and Joseph Brant, were among the first to experience the true value of this region. All in all, these are the personalities whose legacies have defined Greater Utica.

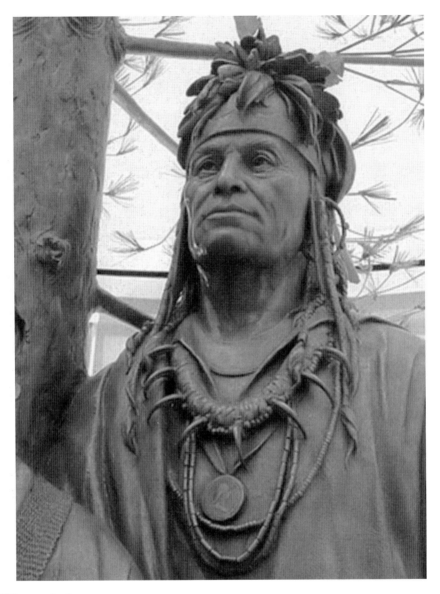

Chief Skenandoah
During the American Colonial period, the swath of land that would become the city of Utica primarily served as a boundary between the Oneida and Mohawk people, as well as a common trade and transportation route. It was during the mid-1700s that native leaders such as warrior chief Skenandoah (1706–1816) were prominent. Originally a member of the Conestoga tribe, Skenandoah was a highly respected warrior as an Oneida, and he became a key ambassador for his people and the Iroquois Confederacy during the American Revolutionary era, serving as an intermediary between disparate factions that included his missionary friend Samuel Kirkland, royal administrators, fellow Iroquois, and early rebel leaders. His leadership was instrumental in both securing native neutrality during the initial stages of revolt and the Oneida's eventual decision to ally with the American rebels. *Skenandoah* is said to have been an early contender for the name of the city that would eventually be dubbed Utica. The chief was recently commemorated alongside George Washington and Oneida leader Polly Cooper with a statue in the National Museum of the American Indian. (Courtesy of Denise Alexandra.)

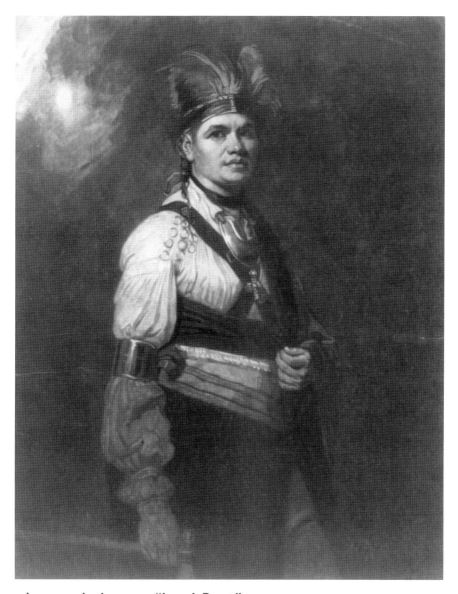

Thayendanegea, also known as "Joseph Brant"
The life of Thayendanegea (1742–1807) is an instructive example of the complexities of life in the Greater Utica area during the late-Colonial and American Revolutionary periods. Thayendanegea would have disembarked with his Mohawk warrior brethren at a spot called Unundadages along the Mohawk River's southern boundary, his war parties rolling over the land that would someday be known as Utica. A convenient crossing point for the Mohawk River, Unundadages is also where Thayendanegea would confer with fellow members of the Iroquois nation, meeting them at the terminus of the Seneca Trail. Trained by western schools and a member of an intertwined Mohawk-English family, "Joseph Brant," as he was also known, became the apotheosis of a generations-old peace treaty between the Mohawks and English during the American Revolution, becoming a feared rival of the Oneidas and their Continental Army allies as a captain in the British army. After the war, Brant remained a respected leader of the Mohawks as they sought greater freedom in the lands that would become Ontario, Canada. (Courtesy of Library of Congress.)

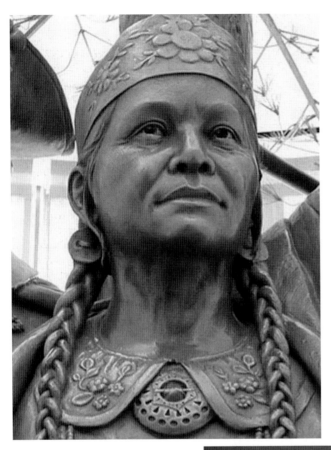

Polly Cooper
Seen alongside Skenandoah and George Washington in a statue titled *Allies in War, Partners in Peace* at the Smithsonian, Polly Cooper is associated with the adventurous Oneidas who came to Washington's aid at Valley Forge during the American Revolution. The "Cooper Shawl," given to Cooper by admirers for her aid to the American rebels, is a treasured Oneida relic. (Courtesy of Denise Alexandra.)

Baron von Steuben
The notable Revolutionary War general (1730–1794) is buried about 10 minutes from downtown Utica near the Steuben homestead where he lived following his service to George Washington's Continental Army. Though Steuben is remembered by his own memorial park in the small town that bears his name, Utica celebrates Steuben as their own adopted hero, naming streets and parks after him and erecting a large bronze statue of "the Baron" at the intersection of Genesee Street and the Memorial Parkway. (Photograph by J. Davis; portrait by W.B. Mays.)

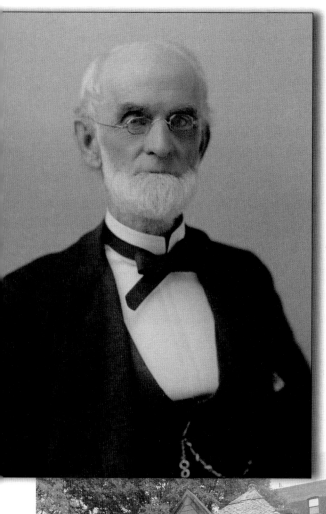

Moses Bagg

At the turn of the 19th century, as the area of the Revolutionary era's Old Fort Schuyler (as Utica was formerly known) became an essential American trade conduit, Moses Bagg saw business opportunity. He left his native Massachusetts and established a small tavern to cater to tradesmen in 1794. His lively hotel became synonymous with the Bagg's Square neighborhood and in its day hosted an extraordinary list of legends, including Washington Irving, Lincoln, Grant, Henry Clay, and Charles Dickens. Even the "forgotten presidents"—Arthur, Cleveland, and Garfield—are remembered as visitors to the landmark. It is said that early settlers at Bagg's Tavern permanently named the city when "Utica" was drawn from a hat amidst a dozen or so other names that likely included "Skenandoah" and "Washington." Despite its pedigree, a memorial to Bagg's tavern is a much overlooked historical gem, partially hidden beneath the North Genesee Street overpass. (Left, courtesy of OCHS; below, photograph by J.P. Bottini.)

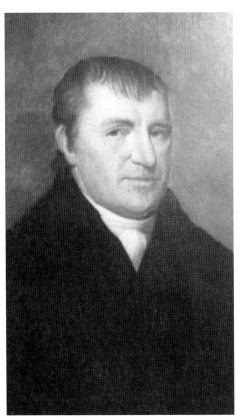

Jedediah Sanger

New Hartford's founding father, Massachusetts native Sanger (1751–1829), bought a number of properties during the late 18th century in what would become known as Oneida County. The land that would comprise much of New Hartford was purchased in 1788 as a portion of a much larger Mohawk Valley parcel owned by national founding father George Washington. The border between New Hartford and the city of Utica would be renegotiated for decades, and the two communities would form a symbiotic relationship over the centuries. During his overall stewardship of a town settled by New Englanders and Northern European immigrants, Sanger would hold a number of municipal and state offices, including the first judgeship of Oneida County and longtime positions as a state assembly and senate member. None of Sanger's homesteads have survived, though many locals assume that a village colonial mansion on Oxford Road was in fact the "Sanger Mansion," a forgivable misconception since Sanger's daughter built this homestead with proceeds from her father's estate. (Left, photograph by J. Davis, courtesy of New Hartford Historical Society; below, photograph by Ryan Orilio.)

Morgan Butler

One of New Hartford's most celebrated early citizens, Butler lived out the Jeffersonian ideal of the "citizen farmer," spending his entire life in New Hartford (1807–1892). He earned significant financial success in farming, and his expertise in modern agricultural techniques was in high demand around the state. The town board noted upon Butler's death that "he was a king and sage counselor, and one who heeded his advice never had occasion to regret he had sought it." Today, locals mostly recognize Butler's name because of the lasting gift he bequeathed to the town: the redbrick, multipurpose municipal office building that he commissioned in 1889. Butler Hall still houses town and village offices and hosts town and village board meetings. (Right, courtesy of New Hartford Historical Society; below, photograph by J. Davis, .)

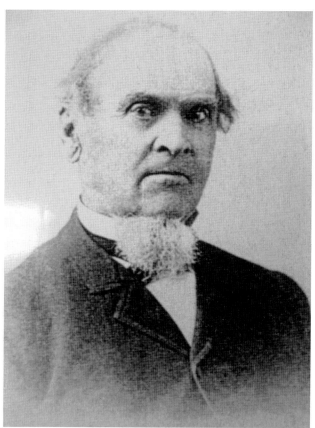

Hugh White

Jedediah Sanger was encouraged to settle in the Mohawk Valley upon hearing of Hugh White's successful settlement in what become known as White's Town in 1784. White, like Sanger, was a New Englander who left his native Connecticut to take advantage of Central New York's natural resources as a land speculator. He also served the fledgling Oneida County in several municipal capacities, particularly as a judge and peace officer. (Courtesy of OCHS.)

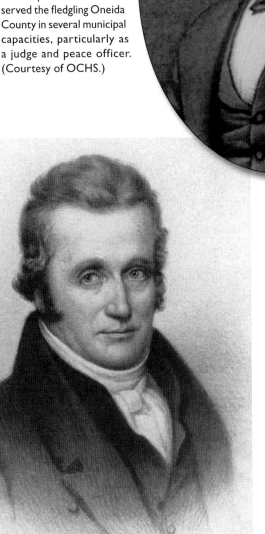

John C. Devereaux

John C. Devereaux was a prominent civic leader in the early 1800s. An Irish immigrant, he served as the first mayor of Utica and was instrumental in expanding worship opportunities in the city, particularly in the establishment of what is now known as Historic St. Johns Church. (Courtesy of OCHS.)

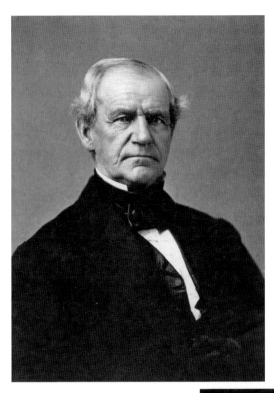

Theodore Faxton
Theodore Faxton (1794 –1881), noted stagecoach hand, financier, city mayor, and railroad executive, is most often remembered these days as a great benefactor, particularly since his name is attached to the hospital that his wealth helped build in the late 1800s. Yet Faxton's greatest impact was as a major innovator of the 19th century; a progenitor of the Associated Press, which coalesced in Utica in 1846 at his urging; and a key financial backer of Morse's telegraph pursuits. (Courtesy of OCHS.)

George E. Dunham
George E. Dunham (1859– 1922) is the namesake of Whitesboro's Dunham Public Library. He was a major leader of the Greater Utica area at the turn of the 20th century, most notably as the president and editor-in-chief of one of Utica's major news outlets, the Daily Press Publishing Company. He bequeathed his family home on Main Street in Whitesboro— the street he grew up on before attending Hamilton College—to create and maintain a public library, which opened its doors five years following his death. To this day, library patrons and staff suggest that Dunham's spirit frequently visits. (Photograph by Ryan Orilio, courtesy of Whitesboro Public Library.)

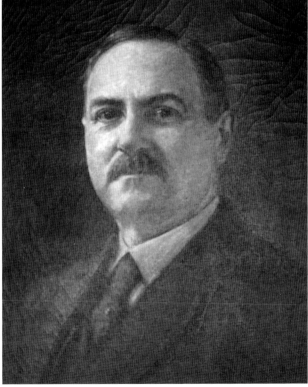

Helen Munson Williams
Utica's matriarch, Helen Munson Williams (1825–1894), acted as chief administrator of a family burrstone business that catapulted her to the very top of the heap of Utica industrialists. Still, she is less remembered as an early American woman executive than as a catalyst for philanthropy. From the steeple of Grace Church—which she commissioned in her own lifetime— to the many contributions of the Munson-Williams and Proctor families a generation later, her legacy is a substantial and sturdy one. (Courtesy of OCHS.)

James Watson Williams
James Watson Williams, husband of Helen Munson Williams, was involved in several of the Munson family business enterprises and served as city mayor during the mid-1840s. He is memorialized for his devotion to the region, particularly by a monument at Watson Williams Park (donated by his daughters Maria and Rachel Williams Proctor), which reads, "As a memorial of one who found tongues in trees, books in the running brooks, sermons in stones, and good in everything." (Courtesy of OCHS.)

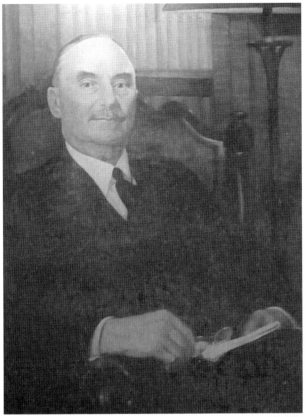

F.X. Matt and Matt Brewing Company

When German immigrant F.X. Matt founded the West End Brewery on Utica's west side in 1888, his was one of numerous local breweries catering to the tastes of Upstate New York communities. Matt's West End Brewery and its competitors appealed to the pallets of the increasingly diverse American public. A perennial business and community leader, Matt, at various points in the early 20th century, headed the Utica Cutlery Company, served on the board that established the Hotel Utica, helped found the Utica Fire Insurance Company, and was president of the Utica Community Chest (an early incarnation of the Utica-area United Way) from 1928 to 1929. (Left, photograph by Ryan Orilio; below, courtesy of Matt Brewing Company.)

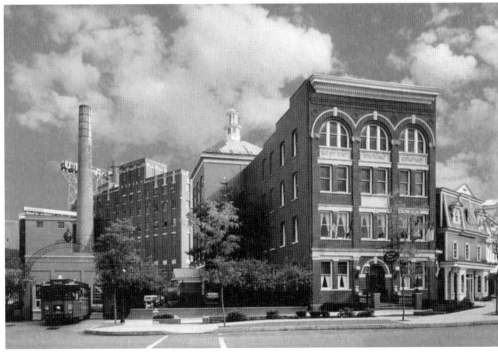

Horatio Seymour

There are, no doubt, countless Americans who have served their country with distinction but have also been judged as being on the wrong side of history, a position that only gets magnified at critical junctures. Horatio Seymour was a leader of the Democratic Party during the tenuous and divisive era of Reconstruction immediately following the American Civil War. He twice served as governor of New York and in the US Senate, and he maintained ties to his Utica roots throughout his entire political life. Though party heads were often instrumental in choosing suitable candidates for office, Seymour was selected by the party he led to run in the 1868 presidential election against Ulysses S. Grant in what historian Eric Foner, in his landmark book, *Reconstruction*, stresses was "the last Presidential contest to center on white supremacy." Character has always played a central role in American politics, and while no one doubted Seymour's political adeptness, it does seem that many questioned his loyalty based on his opposition to Lincoln during the Civil War. Seymour was critical of the Union war effort, particularly the draft policy. When rioters protested against the draft in New York City, an episode elaborately embellished in Martin Scorsese's 2002 film *Gangs of New York*, Governor Seymour allegedly called those who had taken to the streets "my friends." (Photograph by J. Davis; portrait by W.B. Mays.)

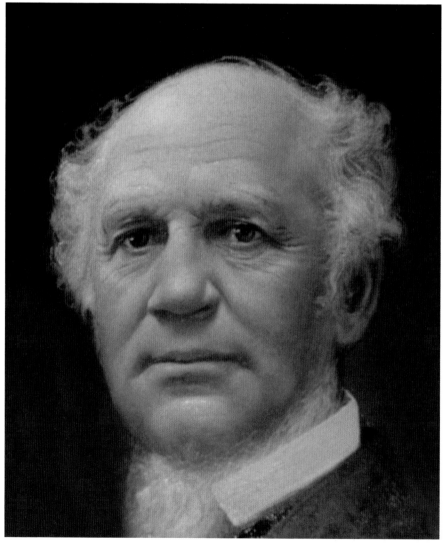

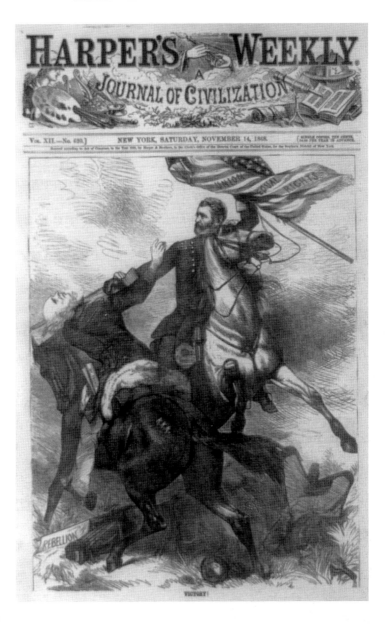

"Victory"

During the campaign of 1868, Republicans were said to have "waved the bloody shirt" to entice voters to consider Democrats responsible for the deaths of thousands during the war. Seymour and running mate Blair, on the other hand, were the standard-bearers of the Democratic Party's opposition to the progressive social agenda of Reconstruction, most notably regarding voting rights and social equality for African Americans. Republicans taunted their rivals with quips like "Seymour was opposed to the late war, and Blair in favor of the next one." Uticans still talk about the rivalry between Seymour and Roscoe Conkling and hypothesize about Conkling's role in helping Grant defeat Seymour in the 1868 election (as depicted in the *Harpers' Weekly* cover art titled "Victory," above) despite sharing the same hometown. Thus, Utica motorists unwittingly pass by the tomb of a fascinating and controversial presidential runner-up when they drive by his grave marker on Oneida Street at the edge of New Forest Hill Cemetery. (Courtesy of Library of Congress.)

Francis Kernan

Known as "a gentleman of the 'old school,'" Francis Kernan (1816–1892) was one of the most influential attorneys of his era, and his term in the US Senate (1876–1882) was just one of a number of prominent leadership roles he filled in the region and throughout the state. Educated at Georgetown, Kernan moved to Utica and began his law practice in the early 1840s. He played Democratic foil to Republican Roscoe Conkling, each competing in the US Congressional elections of 1862 and 1864 (Kernan was the first political victor in 1862 but lost the rematch in 1864). In later years, his political supporters encouraged the notion that he had formed a friendship with President Lincoln when their terms in office overlapped, presumably based on their mutual low regard for the institution of slavery and Kernan's loyal opposition during wartime; such a relationship is difficult to corroborate from the historical record. A longtime advocate for publicly funded common schools, Kernan was a member of the city's board of education in addition to being a New York State Education Department regent. He practiced law throughout the remainder of his public life, resided at Chancellor Square, and was an occasional—albeit unsuccessful—candidate for several other major public offices. His candidacy for the gubernatorial seat in 1872 was harpooned by attacks that focused on his Roman Catholicism. On a greater scale, similar tensions can still be seen within the ongoing, dynamic friction between religion and politics in the United States. Kernan's suspect allegiance to the Catholic Church was captured by Thomas Nast in the cartoon "Our Foreign Ruler?" that depicts Kernan kneeling before Pope Pius IX. The law office of Kernan & Kernan is still located in downtown Utica. (Courtesy of Library of Congress.)

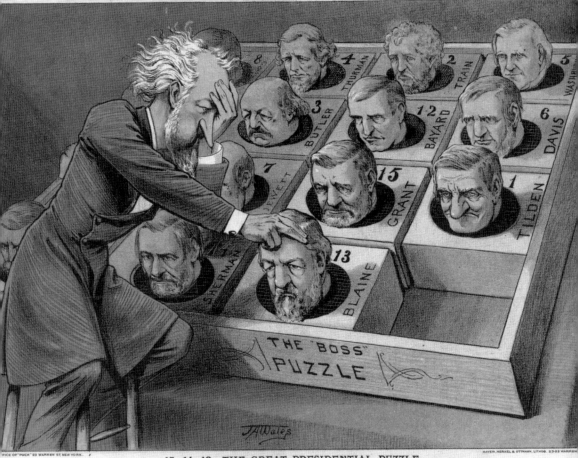

15—14—13.—THE GREAT PRESIDENTIAL PUZZLE.

Roscoe Conkling

Roscoe Conkling was the quintessential political operator from the end of the American Civil War until well into the Gilded Age (1860s–1880s). Notorious for his Washington power plays, Conkling cultivated his acumen for wielding political influence beginning with his term as Utica mayor in the late 1850s. He went on to serve in the US House and then three terms in the US Senate, strongly supporting President Grant in the early days of Reconstruction and spending the better part of two decades promoting a Republican agenda to meet the needs of the party's hard-line "Stalwart" faction. Currying favor, granting patronage, and, as the *Puck* cartoon above would lead readers to believe, placing Washington personalities in just the right place to sway a presidential election were among the many tools "Lord Roscoe" employed in an attempt to dominate his era. Conkling's political star faded during the Chester Arthur presidency when Arthur, as head of state, became less yielding to Conkling's demands than he had been as an Albany-area politician. (Courtesy of Library of Congress.)

Thomas Proctor

Thomas Proctor (1844–1920) was a Vermont native who made his first business fortunes in the city of Utica as a hotelier at the former Bagg's establishment; only later would he get into the realms of industry and finance. During his lifetime, he and members of his family bequeathed public gifts to the city of Utica that are too numerous to mention but most notably include the Utica Public Library and hundreds of acres that make up a vast city park system. Utica's high school—one of the few high schools in Central New York to see a steady increase in enrollment—bears his name. A recently refurbished statue of Proctor greets passersby on the Memorial Parkway as a constant reminder of his stewardship. (Right, courtesy of OCHS; below, photograph by J. Davis.)

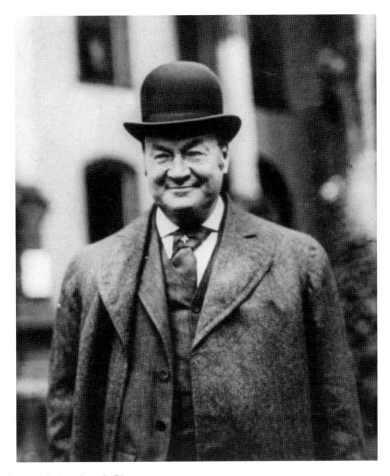

Vice Pres. James Schoolcraft Sherman

When presidential candidate Mitt Romney tapped Wisconsin congressman Paul Ryan as his running mate in the 2012 presidential campaign, it was the first time a presidential hopeful had turned to a sitting member of the US House of Representatives since Pres. William H. Taft asked Utica-area congressman James Schoolcraft Sherman to be his (successful) running mate in 1908. Utica nurtured the Hamilton College graduate's nascent political interests as it had Roscoe Conkling's in the previous generation; he matured from his role as a young lawyer and local political operative to become, by the 1880s, mayor of Utica. He then went on to a successful bid for Congress, where he distinguished himself in the Republican Party as a hard-working and logical man. Sherman's challenge during Taft's White House years was to help the president establish his own identity as a Progressive reformer following the archetypal presidency of Theodore Roosevelt while at the same time preserving his own reputation as a spokesman for the GOP's inherently conservative platform. Historians have noted that President Taft and Vice President Sherman became closer political allies as Taft explored a more conservative political agenda. The president praised Sherman for his abilities to promote his legislative agenda, as well as for his "sunny disposition and natural goodwill to all." "Sunny Jim" was rumored to be a serious presidential candidate in 1912 as the Republican Party sought a potential compromise candidate between Taft and a reemerging Teddy Roosevelt. Yet, with the 1912 presidential election cycle in full swing, an ailing Sherman died in his hometown shortly before Taft and Roosevelt's "Bull Moose" Progressive Party ended up splitting the Republican vote, helping Woodrow Wilson become the first Democrat to win the presidency in decades. Sherman is buried at Forest Hill Cemetery in a large mausoleum that can easily be seen by passersby from the Eagle monument to the Proctor family atop Steele Hill Road. (Courtesy of Library of Congress.)

Frederick T. Proctor and "Fountain Elms"

A member of Utica's "power family," Proctor (1856–1929) was a successful local businessman and, along with his half brother Thomas, a major local philanthropist. He married Rachel Williams, and they made their home in the Williams estate now known as "Fountain Elms," a landmark next door to the Munson-Williams-Proctor Art Institute. The Proctors often joined forces in their ventures, including the establishment of the Utica Public Library in 1904, the extensive municipal park system that bears the Proctor name, and the aforementioned art institute, opened posthumously. (Right, courtesy of J.P. Bottini; below, photograph by Ryan Orilio.)

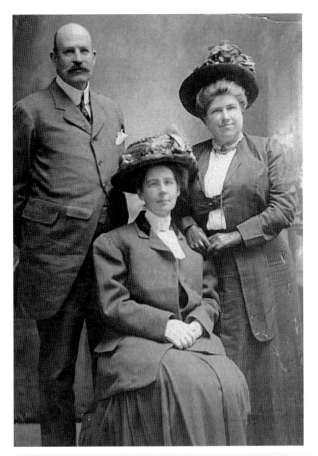

Maria Williams Proctor and Rachel Williams Proctor

Maria Williams Proctor (1853–1935; center) was not only a noted philanthropist but, in many ways, the social conscience of Utica. She contributed several memorials to her husband, Thomas, including the Bagg's Hotel monument (see page 13) and the eagle statue in Conkling Park. To modern readers, her efforts during the Great Depression would seem unimaginable. Maria insured local banks against insolvency and put unemployed locals to work by hiring them to dismantle old buildings in the city, such as her husband's old venture, Bagg's Hotel. Rachel Williams Proctor (1850–1915; right) was the oldest surviving daughter of the Munson-Williams family and played a major role in the philanthropic efforts of her family. Along with her sister, she devoted the considerable art collection of the Williams family as a basis for the Munson-Williams-Proctor Arts Institute (below). (Left, courtesy of OCHS; below, photograph by Ryan Orilio.)

27

Dr. T. Wood Clarke

Dr. T. Wood Clarke (1878–1959) authored a number of books that remain among the definitive texts on their subjects. Born and raised in Utica, Clarke attended Harvard College, went on to Johns Hopkins University, and earned post-medical training in Europe before settling back in the city his family had called home since the early 19th century. A prolific writer, his many books included two essential studies of the region's early history, *The Bloody Mohawk* and *Emigres in the Wilderness*. *Utica: For a Century and a Half*, published in 1952, is still on the shelf of every local historian and is an ideal starting point for essential facts about life in Utica in the decades before World War II. His Cottage Place homestead helps make up the distinctive character of the Pratt Institute neighborhood. (Courtesy of OCHS.)

John Butterfield
Though not a Utica native, John Butterfield (1801–1869) would establish himself as a significant 19th-century innovator in Utica, leveraging its central geographic location to enable his stagecoach mail-delivery business to become a forerunner of one of the modern era's most successful companies, American Express. Butterfield networked with his partners at American Express—and the Wells Fargo Company—to create a communication web that covered the East Coast and extended west from Utica to Buffalo and beyond. Butterfield's Overland Mail, as his arm of the network was called, was crucial to the development of western settlement and business ventures and became an archetype of the western frontier life. Butterfield served as Utica mayor and also built one of the most legendary structures in Utica, the Butterfield House, and a luxury hotel located on the Genesee Street where, among others, Presidents Grant and Cleveland were visitors. (Courtesy of OCHS.)

Albert Mazloom

As a child growing up in East Utica, Albert Mazloom never set out to become a public figure or one of the region's most respected executives and humanitarians. Yet his mother began to instill in him at an early age the qualities that would make Mazloom not only a trusted advisor to high-technology entrepreneur George Cogar but a leader celebrated as Mohawk Valley Chamber of Commerce's Businessman of the Year (2012), and Leading Edge Award Winner for Trenton Technologies (2011), St. Elizabeth Medical Center's Humanitarian of the Year (2007), and recipient of the Oneida County Historical Society's Living Legends Award. His business acumen was first cultivated at the family grocery store on the corner of Mohawk and Elizabeth Streets, where Mazloom says his "natural entrepreneurial capacity" was forged in the highly competitive business environment of the late 1940s and early 1950s. Though the youngest member of the family, Albert was still expected to contribute, and working at his mother's grocery along with side jobs as a shoeshine boy and vegetable peddler inspired a lifelong business philosophy. "Anyone who knows accounting will tell you 'assets minus liabilities equals net worth,' but I have a personal philosophy: 'Cash minus liabilities equals net worth.' This is a principal my mother taught me." Finding the economics classes of Virgil Crisafulli particularly inspiring, Mazloom's everyday business experiences were bolstered by the formal instruction in accounting and economics he received at Utica College, a debt he has sought to repay by serving on the Utica College Board of Trustees and establishing a scholarship fund. In recognition of his support, the Albert Mazloom Atrium to Utica College's Economic Crime and Justice Building was named in his honor. (Photograph by the Utica *Observer-Dispatch*, courtesy of Albert Mazloom.)

H. Thomas "Tom" Clark Jr.

H. Thomas "Tom" Clark has headquartered two significant business enterprises—Mac-Clark Restaurants (consisting of 16 McDonald's restaurant franchises) and the Adirondack Bank (with 17 branches throughout Upstate New York)—in the Greater Utica Region because of a genuine love of the region, which he has always called home. "When you love an area, you want it to succeed," is the ideal that Clark has acted upon through numerous leadership roles over the years. For instance, he helped to establish a regional economic development board known as the Mohawk Valley Edge and also chaired the inaugural board of trustees at his alma mater, Utica College, where he helped to establish the school's independent charter from Syracuse University in addition to erecting the Clark Athletic Center as a memorial to Harold T. Clark Sr. Clark describes himself as an "eternal optimist" who is bullish on the prospects for Greater Utica in the future. "I have loved the people here, and I have loved the work ethic here, it is truly unlike any other place," he explains, "and when you consider how much people have accomplished here over the years, it goes a long way in explaining why folks are so proud of this area." (Courtesy of Mac-Clark Restaurants.)

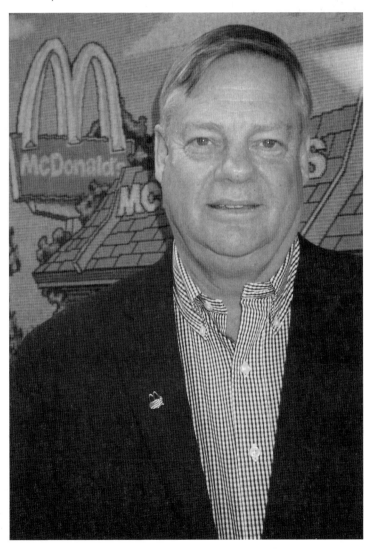

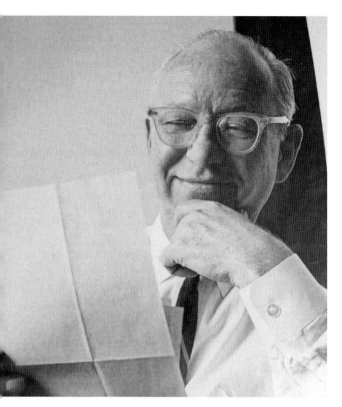

Walter Matt and "Shultz and Dooley"

"My father oversaw a significant era of expansion of our brewery and was a large proponent of many of the new directions the city of Utica would take in the 1950s and 1960s," recalls Nick Matt. Walter Matt (1901–1982) oversaw operations at the West End Brewery from 1951 until 1980, when his son F.X. Matt II took over as president, and the brewery became known as the F.X. Matt Brewing Company. Walter Matt bolstered the production of the brewery's Utica Club brand with a 1950s national television campaign starring a cast of talking beer steins, particularly the adventures of a German stein, Schultz, and his Irish sidekick, Dooley. To maintain the now burgeoning sales of Utica Club during the counter-culture shift of the 1960s, Walter gave the go-ahead for a television commercial series that featured the fictitious "Utica Club" as a happening place where beer drinkers young and old partied together. As brewing historian Maureen Ogle explains, "Inventive, funny, and surprisingly hip for an otherwise old-line, establishment brewery, the ads spoke directly to the same young adults who, as children, reveled in the antics of Schultz and Dooley, and pushed company sales to new heights." When the city of Utica found itself shifting from textile production, Matt and other community leaders formed temporary coalitions to attract new manufacturers to the city. (Left, courtesy of Matt Brewing Company; right, photograph by Ryan Orilio.)

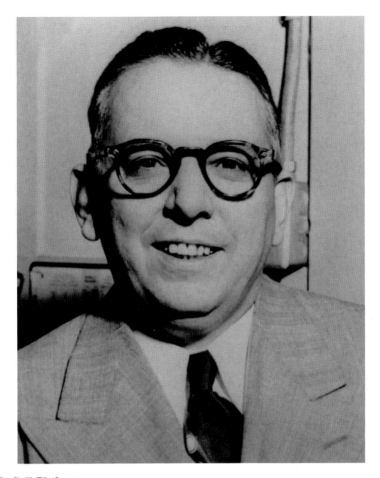

Rufus P. "Rufie" Elefante

Haverford College dean Philip Bean corroborates in his academic work *The Urban Colonist* a fact that many Uticans, particularly in the eastern part of the city, would readily admit in the mid-20th century: "Elefante was the single most important figure in local politics in the 1940s and 1950s." There is perhaps no greater testament to the influence that machine politician Rufie had on Utica life than the fact that, decades after his exit from the political scene, many locals still wax nostalgic about the instrumental role he played in Utica while it was a place that "still mattered." In fact, Elefante's strength as Democratic political machine boss was at its zenith when Utica was threatened with marginalization by bigger metropolitan areas in the years immediately following World War II. He credibly leveraged his relationship with local political coalitions and state and national leaders to redefine the industrial base in the region. Griffiss Air Force Base, General Electric, and several manufacturing plants were established in the region partly because of his lobbying; the organization that would become the Mohawk Valley Water Authority, under Elefante's direction, enabled the expansion of suburbs like New Hartford and Whitesboro. As is always the case in his chosen arena, Elefante was not without his critics and political enemies. The overall influence of his Democratic political base, dependent on the support of Utica's large Italian American population, was buffered by other ethnic interest groups. Elefante was also the subject of political attacks by Republican adversaries and scrutiny by the *Observer-Dispatch*, which reflected the discomfort that many baby boomers felt about machine-style politics. Yet as political reporter Alan Ehrenhalt noted in that late 1980s, "Rufie Elefante is the political boss Utica no longer wants but hasn't learned to live without." For a city looking to redefine itself yet again, Elefante's ability to build coalitions while advocating for the city's large ethnic population is particularly relevant. (Courtesy of OCHS.)

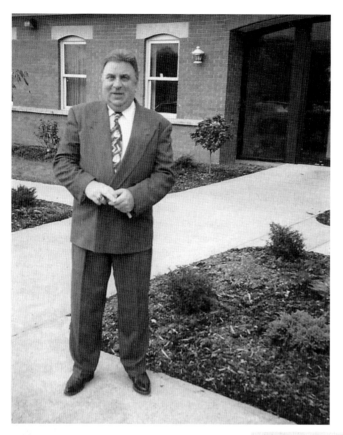

Joseph Carucci
Realtor Joseph Carucci (1941–2010) spent the better part of his last years trying to lay the groundwork for a revitalization of the Greater Utica region. Partnering with Charles Gaetano Construction, Carucci restored the Hotel Utica to its original grandeur. The Mohawk Valley Genesis Group remembers Carucci with the Joe Carucci Community Appreciation Award. "He was able to provide energy, knowledge, vision, compassion, and strong leadership to our region," remembers longtime friend Chris Ossont. "He made a difference." (Courtesy of Carucci Real Estate.)

Tom Cavallo
Thomas Cavallo Sr. began his career in the tavern business in East Utica in the 1940s but chose a central location in the nascent village of New Hartford in 1949 for the establishment of one of the longest-serving bar/restaurants in the region, Tom Cavallo's. Cavallo Sr. operated his restaurant at 40 Genesee Street full time until his son Thomas Cavallo Jr. started to take on more daily management in 1969 when his father became ill. Tom Cavallo Jr., along with his children, still oversees what is arguably the region's most popular and renowned gathering place, noted by numerous travel guides as the place to eat and drink while in the region. "My employees have done the most for me over the years," Cavallo Jr. explains while sitting at his famous bar, "I've been lucky over the years, but with a place like Cavallo's it comes down to location, service, and employees, and I would have to say that employees definitely come first." (Courtesy of the Cavallo family.)

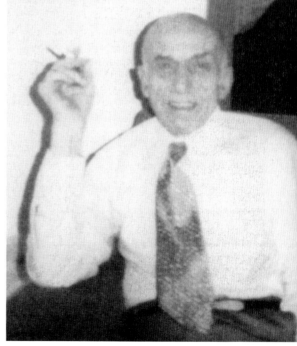

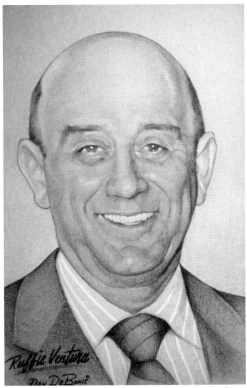

The Ventura Family Restaurant
Ventura's Restaurant has been a Utica mainstay for the last seven decades. Chef Rufus Ventura Sr. (left) began the restaurant on South Street and moved it to its current location on Lansing Street in 1946. With its television tuned to the current Yankee game or latest big-ticket boxing match, the bar at Ventura's was a popular gathering place for sports fans in the 1950s, before television was a household must. The family members are devoted New York Yankees baseball fans, flying a Yankee team flag over the restaurant during the season (lowering it to half-mast following a Yankee loss was once a favorite family custom). Rufus Ventura Jr. and Rufus Ventura III (below) now manage the restaurant, maintaining a classic East Utican family-dining experience. (Sketch at left by Dan De Bonis, courtesy of Ventura Restaurant; photograph below by J.P. Bottini.)

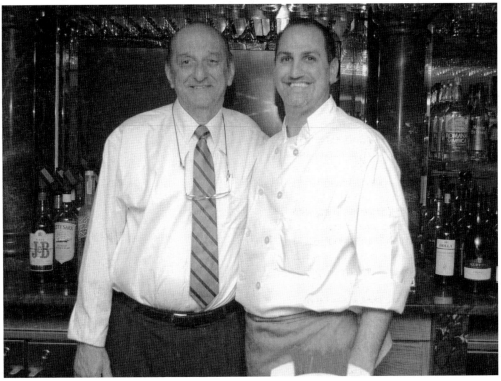

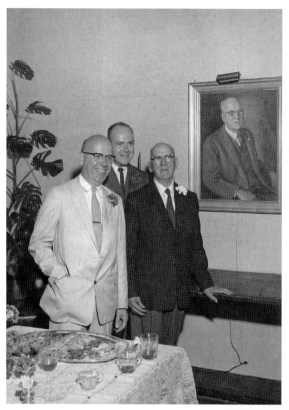

The Sinnott Family and the Bank of Utica

The Sinnott family has nurtured the Bank of Utica since 1927, when founder John J. Sinnott, standing at right in this 1959 photograph with sons Rodger J. Sinnott (left) and John J. Sinnott III (center), moved on from work as an accountant, haberdasher, and textile executive. The significance of local ties was—and continues to be—crucial to the bank's success. As a 1920s-era newspaper column suggested of Sinnott, "He has more friends than there are quarts of hooch in Utica and each day he finds the morning sunlight fresh and fair." Though the Bank of Utica evolved from its early start as a commercial building and loan tucked away off the main thoroughfares, it has been a stalwart of downtown Genesee Street since the 20th century (pictured below during the 1950s). A perennial family company, the bank is currently presided over by its third generation of leadership, Thomas Sinnott. (Both, courtesy of the Bank of Utica.)

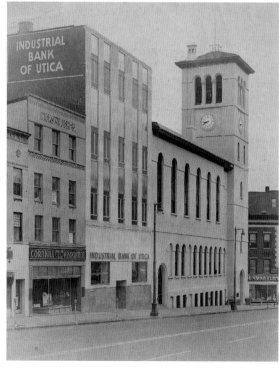

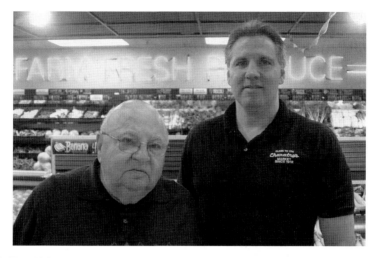

Chanatry's Food Markets

Bill Chanatry, current president of Chanatry's Food Markets on French Road in Utica, attributes the century-long success of his family-owned market to hard work, family pride, and community values. "What's true of the Central New York attitude is its strong work ethic, and that spirit of a small town that, regardless of our changing size over the years, weaves itself into our sense of community," Chanatry states. "The variety of ethnic groups living in Utica has certainly fostered a broader view of the people we serve and the world around us." Raymond, Michael, and Yorhaky Chanatry established their first food stores on Bleecker Street in 1912 and expanded to other locations on Albany Street and French Road over the course of the next 100 years. Bill Chanatry (left, with son Mark) credits the store's formidableness to its founders who "imbued us with a work ethic that included a core characteristic of wits and passion that stays with us to this day." The Chanatry's legacy now revolves around its French Road operation (below), where it was recently awarded the Mohawk Valley Chamber of Commerce Business of the Year Award in 2010. (Photographs by J. Davis.)

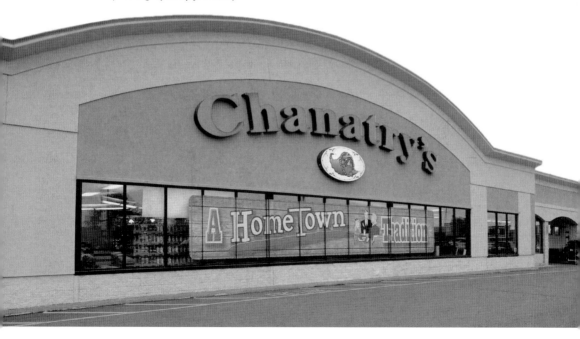

Gabriele Alessandroni and the Florentine Bakery

The Florentine Bakery has been a mainstay in East Utica for decades. It was first established by Joseph Borgovini and Vincenzo Gennaro in 1928 and found a permanent home in 1942 at 667 Bleecker Street, where it still produces a wide selection of classic Italian American confections such as the cannoli (an alleged favorite of Baseball Hall of Famer Phil Rizzuto). Management of the shop—and stewardship of its popular recipes—passed through a number of families, including the Terminios, Vitullos, and Alessandronis. Baker Gabe Alessandroni (pictured) was associated with the bakery for nearly four decades until he passed the baton to extended family, the Alesias, in 1993. Jared Alesia has baked at the Florentine since 1995, preparing pastry and cakes daily for special events and for a franchise outlet Café Florentine located in New Hartford's Consumer Square. (Right, courtesy of Florentine Bakery; below, photograph by Ryan Orilio.)

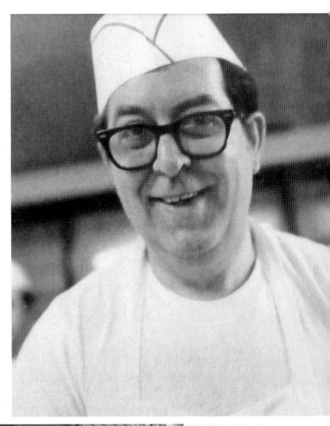

The Half-Moon Cookie

One often hears that life is about balance, and Utica's legendary half-moon cookie only reinforces such wisdom. There is no question that Utica pastries are of the same variety that one will find in New York City and Boston and many other communities throughout the Northeast. Yet bakers in Utica have undoubtedly developed their own approach to many confections, like their approach to the black and white half-moon cookie. Though the half-moon comes in several varieties, it is still basically a cupcake-like base topped with vanilla and chocolate frostings, each spread on opposite sides of the cookie. Half-moon enthusiasts are divided by their frosting preferences; some favor fluffier vanilla frosting over the buttercream variety, while others prefer only one flavor of the frosting on their cookie (which obviously defeats the yin-yang quality of the cookie). Several bakeries have themselves become legendary for their approach to the half-moons, including Holland Farms Bakery, Hemstrought's Bakeries, and the Gingerbread House Bakery. One of the first remarks made by former president Bill Clinton, a master of the "all politics is local" maxim, during a 2004 visit to Hamilton College was a reference to his and Hillary's great of love of this Central New York cookie. (Photograph by J. Davis.)

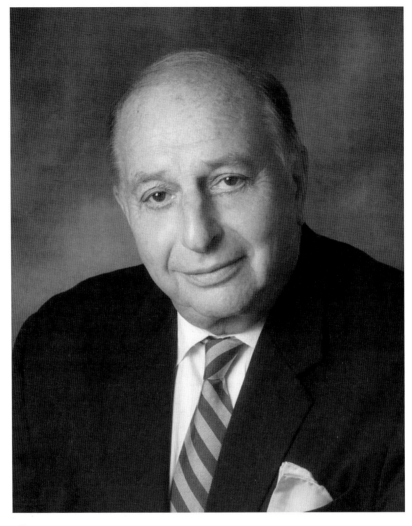

F. Eugene Romano

"American history could just as easily be called American economic history, because that is the truly great story of our country," says F. Eugene "Gene" Romano, philanthropist and prominent leader of several international businesses (among them Pacemaker Steel & Piping Company). Romano's acumen for business was cultivated by his father—a respected public accountant in the Utica area—who recognized his son's potential when Gene proposed, on the cusp of adolescence, that he become the key distributor of out-of-town New York newspapers. Gene Romano took an initial investment of $1.26 to purchase copies of the *New York Times* to sell to the Sunday after-church crowd and spun his profits into a business career that would span nearly eight decades. His studies at Hamilton College and service in the Korean War bolstered his natural business perspective and his dedication to his community. His reverence for the honorable, common-sense business values that he espouses to this day is captured in a treasured piece of memorabilia: a ledger sheet maintained by his father to track Gene's repayment of a personal loan granted by his dad, paid with interest well in advance of the date expected by creditor and debtor. Romano, who holds honorary doctorates from his alma mater and Utica College, has been instrumental in countless philanthropic endeavors, including capital expansions of St. Elizabeth's Hospital and the New Hartford Public Library, scholarships at Hamilton and Utica Colleges, and the creation of the F. Eugene Romano Hall for Science and Technology at Utica College. (Courtesy of Pacemaker Steel.)

CHAPTER TWO

Innovators

As of this writing, many people from the Greater Utica area are hopeful that the region will become one of the several locations in New York for nanotechnology investment. Several steps are already underway to draw the necessary talent and treasure to SUNY Institute of Technology (SUNYIT) to make Utica a larger home, once again, to the high-technology world.

Utica was a focal point of innovation for generations, particularly in manufacturing technology and communication, but also in terms of culture and social justice. Many innovators found that the small-town nature of Utica city life provided them with an essential grounding they needed before their respective fields beckoned them around the country and world. Others appreciate not only this latter quality but also a no-less-powerful feature: the sense of liberation to try new things away from the limelight of much bigger cities where business and personal risks may be much more costly.

Some future historian will likely note Utica's welcoming of refugees from war-torn countries of the 1990s as yet another of its innovations. In 2010, Peter Applebome of the *New York Times* reported in an article titled "In This Town, Open Arms For A Mosque" that while many American communities struggled with the spread of Islam during the War on Terror, Uticans seemingly embraced newcomers of once unfamiliar faiths and customs. As Applebome suggests, "if we had today's stories told by Frank Capra rather than by talk radio, there are more than a few that could be told in this town, which is being revived by immigrants and is embracing difference not in the didactic style of do-gooder moralizing but as a continuation of what Utica has always been." Many Greater Uticans would agree.

Why? While the city was the hub of innovation in manufacturing and communication and the post–World War II progenitor of Silicon Valley, it has also been the home of dedicated advocates for human rights and public health, visionary artists, culinary masters, and brewing legends. Gerrit Smith, George Cogar, Samuel Morse, and many others are essential characters in Utica's story.

John Zogby

"You live in the Land of Oz, and the candidates are the Tin Man, who's all brains and no heart, and the Scarecrow, who's all heart and no brains. Who would you vote for?" Unique polling questions such as this (to distinguish voter preference between "Tin Man" Al Gore and "Scarecrow" George Bush in the 2000 presidential election) have helped Utica-area resident and political pollster John Zogby integrate more art into political science, thus making him one of the most insightful names in American politics over the last 25 years. Zogby argues that his Utica vantage point provides an edge over polling firms in New York City or Washington, DC, by allowing him to stay in touch with authentic, everyday concerns that his colleagues may not anticipate while at the political epicenter. Though his work has taken him all over the world, he credits his hometown with preserving the progressive social and scientific values that date back to Utica's 19th-century promotion of abolitionism, women's rights, and Samuel Morse's famous telegraph machine. To Zogby, this is what makes Utica an ideal place for young people to take the first steps in discovering a greater world, a process he describes in his best-selling book *The First Globals*. "Richard Florida, a friend of mine who writes about the creative class [*The Rise of the Creative Class*, 2004] talks about a community's greatness measured in three 'Ts' : technology, talent, and tolerance. We do well in all three—but I am especially proud of the tolerance." Though he spends much of his time in the fast-paced world of internet media these days, writing columns for the likes of *Forbes* and the *Huffington Post* (though he still finds time to impart has expertise at J-Z Analytics, a new polling and marketing firm) Zogby suggests that folks set a moment aside for the sort of nourishment Utica has to offer. "This is a good place to explore ideas—it is clean, diverse, tolerant, and has a vibrant arts community and presence. Like a good cigar or beer, it has to be appreciated." (Courtesy of John Zogby.)

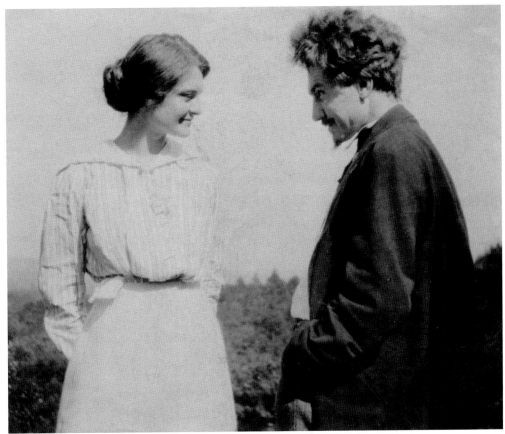

Ezra Pound

Considered by many scholars to be the most influential poet of the modern era, Ezra Pound (1885–1972) is said to have frequented the bustling Utica theater district that stretched from Bleecker Street to Lafayette Street while he was a student at nearby Hamilton College. Scholars suggest that Pound began work on his highly regarded *The Cantos* while a student at Hamilton. It is also said that he met one of his early poetic inspirations, pianist and composer Katherine Ruth Heyman (1877–1947), after she played a show in Utica. Pound is seen here with his wife, Dorothy Shakespear. (Courtesy of Hamilton College.)

Samuel F.B. Morse

Famed telegraph inventor Morse (1791–1872) was a frequent visitor to Utica, finding his first financial backers in two men who would become legends themselves: John Butterfield and Theodore Faxton. Morse's wife was a Utica native, and Utican A.S. Chubbuck became one of the first inventors to proliferate telegraph-signal–relay machines, a technology based on Morse's research and early telegraph designs. (Courtesy of Library of Congress.)

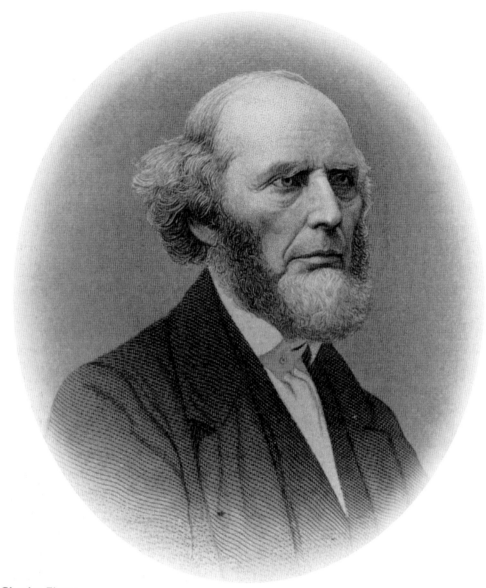

Charles Finney

Local history students learn that Utica was one of the most active locales of the American Second Great Awakening, a significant social movement that inspired countless Christian denominations and made preachers such as Charles Finney (1792–1875) into national icons. Finney spent many of his early years in the Utica area and used the city as the center for an expanding base of preaching and revival meetings. "While making my home in Utica," Finney recounts in a memoir chapter titled "Revival At Utica," "I preached frequently in New Hartford, a village four miles south of Utica . . . I preached also at Whitesboro another beautiful village, four miles west of Utica; where also was a powerful revival." Finney includes many reminiscences of his formative years in Utica, including an incident in which he says his sermons forced the looms in New York Mills to shut down, since as the factory boss said "it is more important for our souls to be saved than that this factory run." Finney would become a national figure in the Second Great Awakening from the mid-1820s into the early 1830s, moving across the Northeast to further his mission and also becoming the second president of Oberlin College. (Courtesy of OCHS.)

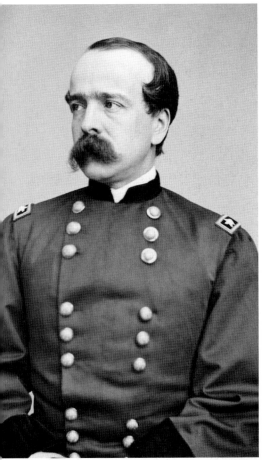

Daniel Butterfield and "Taps"

Tradition has it that the mournful melody one hears at military funerals is the somber, contemplative work of an amateur composer, Utica native Maj. Gen. Daniel Butterfield (1831–1901), following his experiences at the Battle of Gaines Mill, Virginia. A prominent local businessman as well as a distinguished brigadier general during the American Civil War, Butterfield is said to have adapted a previous bugle call (titled "Tattoo") that he had heard over the course of his military service into a melody that, with some reworking, became synonymous with a soldier's final call to duty: "Taps." Retired US Army Field Band leader Chief Warrant Officer 4 Josef Orosz, author of the booklet *The History of Taps*, notes that Butterfield conditioned his regiment to respond to a melody similar to "Taps" as an alert of information unique to the regiment and then ordered his bugler (as depicted in the painting below) to rework the regimental call to reflect the mournful mood following Gaines Mill. Orosz told *Rochester Review* that he hopes that when musicians play "Taps," it is with the deep reverence that Butterfield intended: "If someone is going to play 'Taps' at a funeral, it must be exactly as it was intended: a prayer for the fallen hero. No changes, no variations." (Left, courtesy of Library of Congress; below, courtesy of Berkeley Plantation.)

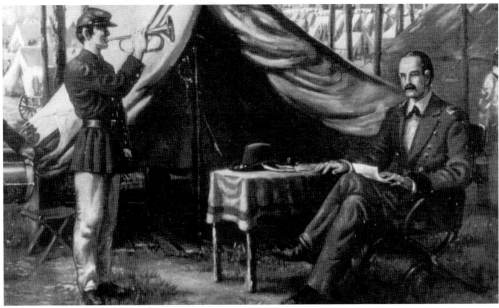

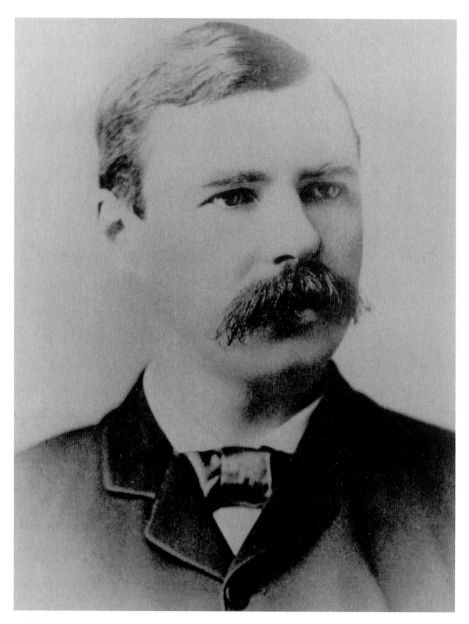

Harold Frederic
One of the most notable writers of the late 1800s, Harold Frederic (1856–1898) was at first widely read as the London-based foreign affairs correspondent for the *New York Times* before becoming a famous novelist. His writing career began at newspapers in Utica and Albany, and though his work took him far from home, nearly half of his fictional works are set in Utica area, including *The Lawton Girl*, *In the Valley*, and his most celebrated international bestseller, *The Damnation of Theron Ware* (1896). *Theron Ware*, considered a masterpiece by contemporaries, earned the praise of F. Scott Fitzgerald and, later, Edmund Wilson. Set in the fictional town of Octavius, the novel explores the struggles of a young priest, with many points in the plot reflecting characteristics of Utica-area churches. Prof. Eugene Nassar argues, "The novel is subtle and powerful and in its ironies and ambiguities, reflective of life's complexities." (Courtesy of OCHS.)

Gerrit Smith

A third-party presidential candidate on multiple occasions, Utica attorney Gerrit Smith (1797–1874) was first called to public life when galvanized by local events in the mid-1830s that brought the issues of American slavery to his doorstep. Though at first a proponent of the resettlement of African Americans to their ethnic homelands, Smith began to move in abolitionist circles. He helped the city circumvent a pending public-safety disaster by hosting the controversial convention of the New York State Anti-Slavery Society in 1835 after it caused considerable commotion among various factions in the city; he eventually served as the organization's president. Events such as the so-called "Utica Incident" of 1836, in which an incarcerated runaway slave was freed by armed abolitionists, only furthered Smith's new abolitionist resolve. Such personal commitment inspired Frederick Douglas to dedicate *My Bondage and My Freedom* to Smith "as a slight token of esteem for his character, admiration for his genius and benevolence, affection for his person, and gratitude for his friendship." *The New York Times* wrote that "the history of the most important half century of our national life will be imperfectly written if it fails to place Gerrit Smith in the front rank of the men whose influence was the most felt in the accomplishment of its results." Though all schoolchildren learn of John Brown's famous raid on Harper's Ferry as an event that helped ignite the American Civil War, most students do not know that Smith was one of the Secret Six who helped finance the event. As Jason Mitchell, principal of Poland Central School and a Smith scholar, notes, "Smith has become the forgotten abolitionist . . . his fight to reform nearly every aspect of 19th-century American society have been largely forgotten. Consequently, 'the history of the most important half century of our national life' was indeed imperfectly written." (Courtesy of Library of Congress.)

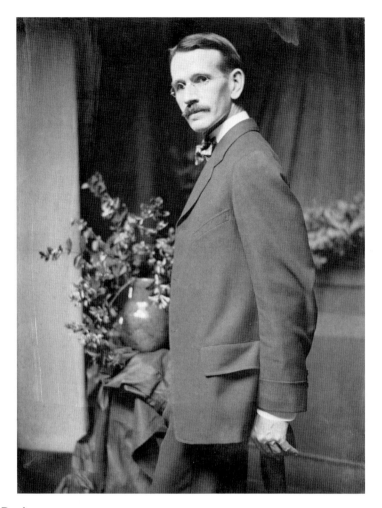

Arthur B. Davies

New York Herald Tribune art critic Royal Cortisoz described Utica native Arthur B. Davies as "a man of genius" and a "boon to American painting." Though Davies pastels and paintings can be found in nearly every major art gallery in the world, his standing as a giant of modern American art has diminished with each passing year. In retrospect, it is hard to underestimate Davies's influence on the world of art, whether as one of the Eight—the group of groundbreaking modern American painters that also includes George Bellows and Robert Henri—or as the sorcerer behind the 20th century's greatest work of exhibition magic: the watershed 1913 Armory Show in New York City. The Armory Show would be the first American exhibition of works by dozens of artists, including Picasso and Matisse, contextualized alongside the work of the Eight. Davies grew up on Hotel and Court Streets in Utica and first studied art with local mentor Dwight Williams, who encouraged Davies to find inspiration in the Mohawk Valley's natural landscape and later describing him as "a young genius of the highest order." Davies biographer Bennard P. Perlman suspects that his subject's stature as an artist has not had the same influence as some of the greats he chose for the Armory Show due to myriad factors, including changes in artistic taste among critics, curators, and art dealers during the Great Depression; the destruction of multiple Davies works in a fire; and the lack of a central executor for his estate. Davies died in Florence, Italy, in 1928. It was soon thereafter discovered that Davies had been living a remarkably complex personal life, with bereaved widows in both Italy and the United States as a well as an impressive list of mourning benefactors with whom he had been personally involved throughout his career. (Courtesy of Library of Congress.)

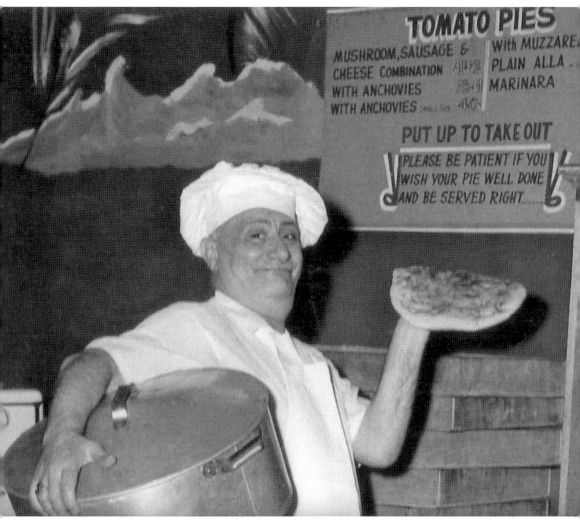

TOMATO PIES

MUSHROOM, SAUSAGE & with MUZZARE...
CHEESE COMBINATION $1.42 PLAIN ALLA ...
WITH ANCHOVIES 25.11 MARINARA
WITH ANCHOVIES Small Size 40¢

PUT UP TO TAKE OUT

PLEASE BE PATIENT IF YOU
WISH YOUR PIE WELL DONE
AND BE SERVED RIGHT......

Eugeno Burlino of O'Scugnizzo's Pizzeria
"We don't own this place, the customers do," says Steve Burline, obviously proud of the devoted following that his family-owned O'Scugnizzo's Pizzeria has fostered for decades. Burline and his partner, brother Mike, are the third generation of "Burlinos" to make their grandfather's innovative and signature pizza on Bleecker Street in East Utica. Necessity was the mother of invention for Eugeno Burlino, who, for practical purposes, topped his pizza in the reverse manner to make the dish more easily transportable. Carrying a stack of pizza shells in a large kettle throughout the neighborhood, Burlino would top his pizzas with warm tomato sauce and Romano cheese to order. Being an early version of the pizza deliveryman in the predominantly Italian American neighborhood meant that Burlino would often hear "scugnizzo, ven acqa," meaning "street vendor, come here." The "upside down tomato pies" became synonymous with the phrase, and thousands of Uticans have dined at O'Scugnizzo's since Eugeno opened his first pizzeria in 1914. Eugeno's son Angelo "Chops" Burline took over the reins upon his father's death in 1958. Under the third generation of family ownership, the pizzeria now ships pizza to online customers throughout the country and has licensing agreements with several local restaurants. (Courtesy of Steve Burline.)

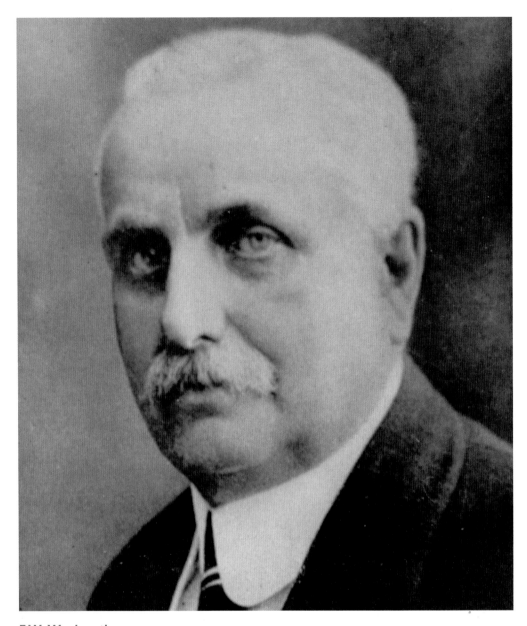

F.W. Woolworth
Woolworth's department store was a shopping favorite in the Greater Utica area for nearly a century until the early 1990s, when several area Woolworth's—like the flagship store on Utica's Genesee Street—closed their doors for good. In fact, what happened to Woolworth's in the Greater Utica area was a sign of the times for Woolworth's stores around the world. To shoppers during the Cold War years, the closing of Woolworth's would be analogous to the closing of Wal-Mart or Target stores today, as Woolworth's had become, by the end of the 1970s, the largest retailer on the planet. F.W. Woolworth (1852–1919) had an unsuccessful initial attempt at retail in Utica in the late 1870s, but profits in other communities gave him inspiration. As explained in Then & Now: *Utica,* "Giving it another try in downtown Utica in 1888, Woolworth's became a mainstay on Genesee Street between Elizabeth and Bleecker Streets, in a building with a long retail tradition." (Courtesy of OCHS.)

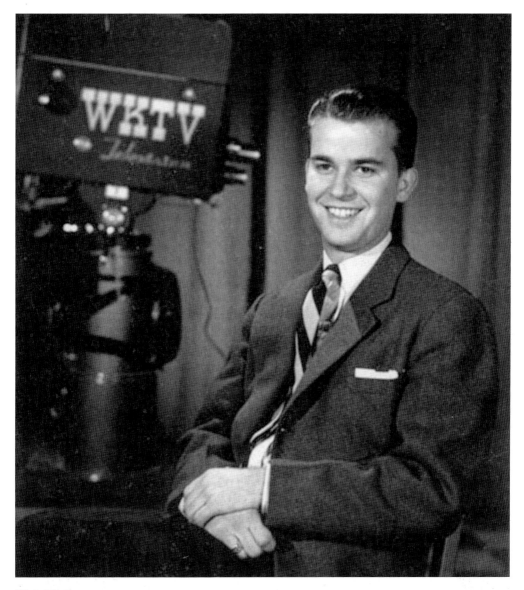

Dick Clark
Dick Clark went on from the mail room at Utica's WRUN-AM radio to become a legendary personality in American entertainment. His first on-air stints on WRUN-AM (which was owned and operated by the Clark family) were in news and weather, and after graduating from Syracuse University in 1951, he found his first job in television news at WKTV-Utica. Success in Utica brought Clark opportunity in the larger Philadelphia market, where he was a disc jockey until the radio station's parent company decided to try him as a fill-in host of a new musical program on television. *American Bandstand*, as it would eventually be known, became an iconic coast-to-coast television show by 1957 and was a cultural mainstay for decades, introducing countless soon-to-be-famous entertainers to millions of American viewers. Clark's television appeal secured a job on the show for decades, and his involvement in other show-business projects would expand considerably. He was the regular host of the Emmy-winning game show *$10,000 Pyramid,* and his *Bandstand* fame was eventually equaled by his role in ushering in the New Year on ABC's long-running Rockin' *New Year's Eve.* (Courtesy of WKTV.)

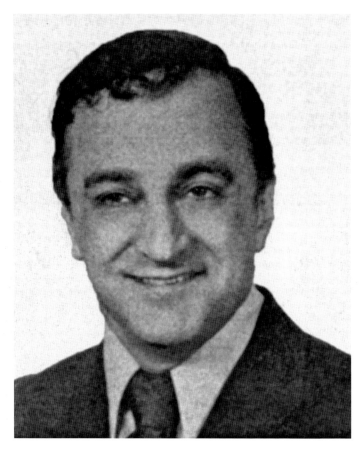

Edward Hanna

Edward Hanna (1922–2009) was politically incorrect before the phrase was popularized in the 1980s. He also was a novelty in mid-1970s politics: a multimillionaire who wins his city's mayoral election, agrees to a $1 salary, and makes national headlines for a rabble-rousing public persona. He also defied the adage that "there are no second acts in politics" by winning reelection as mayor nearly 20 years later. Newspapers like the *New York Times* found Hanna fascinating if for no other reason than the fact that he was a Lebanese American political independent who, after making millions by devising a new photochemical process for carnival-style photograph booths, decided to run for mayor and buck the political establishment by refusing to paint a rosy picture of the fading Rust Belt city he chose to lead. Part of his governing strategy was to talk to anyone who would listen about Utica, even if it meant profiles in adult-only magazines like *Hustler* or as the subject of the coveted (at least in the 1970s) *Playboy* interview. *People* tried to sum up Hanna in the title of the magazine's 1974 feature: "Mayor Hanna is (A) A Saint (B) a Publicity Hound (C) Both of These." He served as mayor from 1973 to 1977, vowing to redefine the city by constructing new public space like Terrace Park and the (failed) La Promenade as well as creating alliances with waning machine politicians such as Rufie Elefante, whom Hanna had harshly criticized on his road to city hall. Local historian Frank Tomaino, who once covered Hanna as an editor for the *Observer-Dispatch*, suggests that "Ed Hanna really cared about the city, and his notions of revitalizing the city were practical." After promising never to return to politics after a loss in 1977, Hanna made a comeback in mid-1990s and once again brought Utica back into the national media scene, particularly in a notorious appearance on a CBS News special where he complained so much about the city he governed that it equaled in candor a quip he made back in the 1970s: "I'm the mayor of a lousy city." Hanna resigned his office in 2000 amidst a controversy and retired from public life until his death in 2009. (Courtesy of OCHS.)

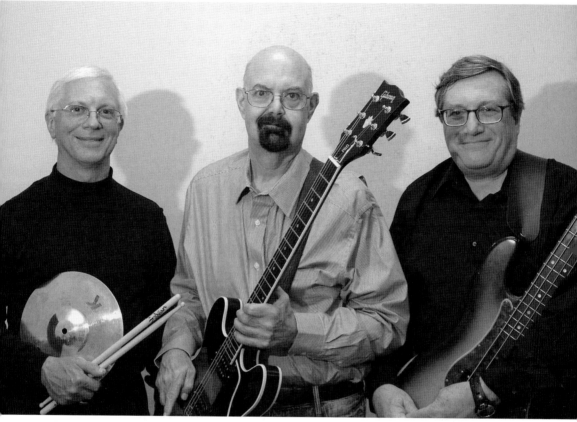

Carmen Caramanica

"There is obviously something in the water here because this area creates good musicians," jazz guitarist and music professor Carmen Caramanica (center) says, "more than from places that would supposedly have all the advantages in music." Caramanica's judgment comes from decades as one of the most respected professional musicians of the Greater Utica area who, like his many students, first developed their crafts as entertainers on the local scene. A childhood accident left Caramanica hitched to a hospital bed in his early teens, and during his convalescence he became a self-taught guitarist. Like so many of his generation, Caramanica played in teen rock-and-roll bands in the 1950s. Yet unlike others with rock-and-roll dreams, Caramanica was scooped up by early rock act Jimmy Cavallo and the House Rockers on their way through town, a moment of musical fate that would lead Caramanica on an all-star musical journey for the next two decades. He played every major venue of the day as musical arranger and director for R&B legend Lou Rawls, played lead guitar for successful 1970s pop singer Tony Orlando, and worked on *The Tonight Show* and soundtracks for major motion picture. These days, Caramanica can often be found at his music school and recording studios in the village of New Hartford, though one can still catch him playing and recording with the Carmen Caramanica Trio, with Cosmo Castellano (right) on bass and Rick Compton (left) on percussion. "I'm happiest playing with these guys, we've been playing together for 30 years . . . my bucket list is right here!" (Courtesy of Carmen Caramanica.)

George Cogar

If George Cogar were to propose a high-technology company today of the sort that he planned in the early 1980s, he would be greeted as a savior to a much-beleaguered regional economy. Cogar was one of the few at the forefront of the personal-computer revolution for nearly a quarter of a century, during which he led the implementation of the groundbreaking keyboard-to-tape data-processing technique, a step in computer evolution that made UNIVAC a darling of the early computer industry. Cogar was the technical and entrepreneurial innovator behind several local and multinational companies, including Mohawk Data Sciences, Data General, Computel, Trenton Technologies, and Deerfield Systems. "My grandfather believed in challenging the standard expectations of the day," computer executive (and Cogar grandson) Jason Tallman says, "and whenever people mention my grandfather's obvious genius they reinforce how much he believed in his people, and how encouraging he could be of new innovators, even if they were his business competition." Before his untimely disappearance on a Canadian hunting trip in autumn 1983, Cogar and his associates at Cogar Informational Systems proposed ramping up their desktop-computing research-and-design efforts to immediately redefine the nascent personal-computing industry. (Courtesy of Cherylynn Tallman.)

Robert Esche

"It is up to the current generation to keep Utica going; it is up to the next generation to make Utica a vibrant place again," says Whitesboro native Robert Esche, an Olympian and professional hockey player. Esche's sense of mission—to do his part to propel the region forward—is informed by his world travels and appreciation of Utica's role in American history. Esche's Aqua Vino restaurant, which sits along the Erie Canal, is filled with classic snapshots of Utica in its early-20th-century heyday and is one of the many ways that Esche shares his passion for history and his love for "a community with rich character." Esche hopes that his business ventures in the region—which include a Westmoreland organic farm, philanthropic endeavors, and establishment of the Utica Comets AHL hockey team—will provide the next generation the momentum it needs to write Utica's next chapter. Esche has played professional hockey as a goalkeeper for the Phoenix Coyotes (1999–2002) and Philadelphia Flyers (2002–2007), as well as minding net for the 2006 US Winter Olympic Team in Turino and participating on several European professional clubs (2007–2012). "I always knew Oneida County was going to be the region where I hung my hat at the end of the day," Esche shares in his restaurant's quarterly magazine. "I couldn't wait to get back and bring all my ideas and stories with me from our world travel experiences." (Courtesy of Robert Esche.)

David D'Alessandro
Lifetime Achievement, Class of 1972
Inducted, 2009

David D'Alessandro

A Proctor High School and Utica College graduate, David D'Alessandro has had a highly accomplished career in business, most notably as chief executive officer of John Hancock Financial Services. Author of the best-selling *Warfare* series of business books, he is also regarded as an authority on sports marketing, having been a former partner of the Boston Red Sox and a catalyst for John Hancock's sponsorship of the Boston Marathon. D'Alessandro is a Lifetime Achievement member of the Utica College Sports Hall of Fame, and the football stadium at Proctor High School now bears his name. (Photograph by Ryan Orilio.)

Peter Corn

Years ahead of the trend of eating local and organic foods, Peter Corn started a small health-food store in the village of New Hartford, catering to customers looking to supplement their diets with the latest approaches to nutrition and exercise. Today, Peter's Cornucopia is a local institution, located in the New Hartford Shopping Center and featuring a wildly popular café and extensive offerings of gourmet and organic foods from around the region and all over the country. (Photograph by J. Davis.)

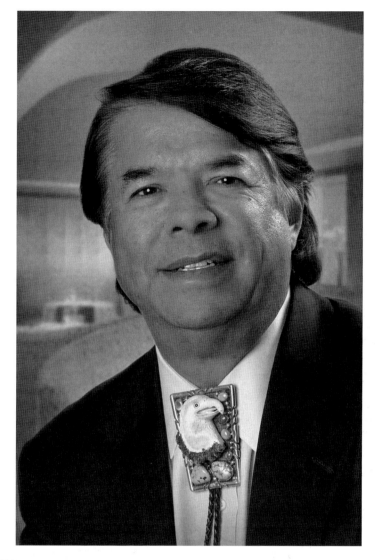

Ray Halbritter
The Turning Stone Casino and Resort, just a short car ride away from Utica, has been the source of both considerable awe as well as public-policy debate for the past two decades. Turning Stone has become the setting for world-class golf courses, attracting celebrated talents such as Tiger Woods, and has earned the highest accolades in the hospitality industry. Meanwhile, many Upstate New Yorkers have debated what all of its success means in terms of taxation policy and land-ownership rights for the Oneida Indian Nation. Nevertheless, much of the Turning Stone's success has rested on the leadership of Ray Halbritter, Oneida Indian Nation representative for more than three decades and chief executive officer of business operations. Halbritter, a graduate of Syracuse University and Harvard Law School, has become one of the most admired businessmen of the Greater Utica region as the Oneida Nation employs thousands of locals at its resort. Halbritter has been acknowledged countless times with local and national awards, including recognition as a Paul Harris Fellow by Rotary International, the Central New York Sales and Marketing Executives Crystal Ball Award, and the Syracuse University Distinguished Entrepreneur Award. Additionally, he advises countless boards, including the Mohawk Valley Edge and the Harvard University Native American Law Board. (Courtesy of Oneida Indian Nation.)

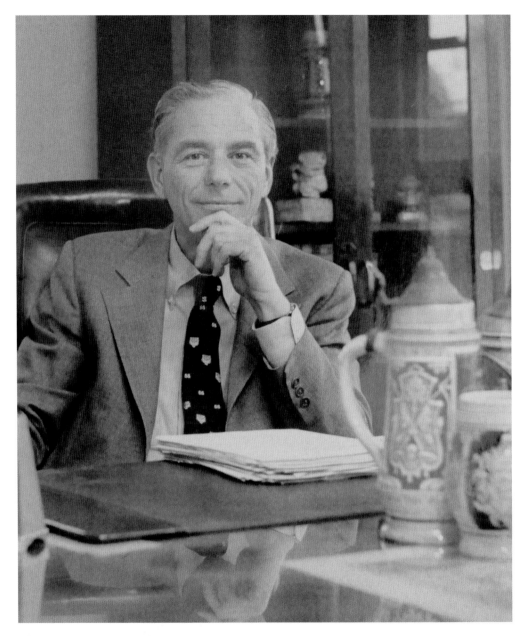

F.X. Matt II

F.X. Matt II became a Utica icon through much of the latter part of the 20th century, symbolizing the small-town business owner who somehow managed to compete with big-brand competition, particularly with his hometown in a state of decline. Like his father, Walter, before him, F.X. was active in countless civic organizations that aimed to promote the region's economic and social fortunes, including the United Way and the Utica Boilermaker Road Race. Introducing the first Saranac beer to little fanfare in the mid-1980s, Matt and his brother Nick redirected the company to focus on the development of a Saranac line of beers, featuring a lager, black-and-tan, and pale ale. Matt was president of the brewery beginning in 1980 and served as chairman under a new company configuration from 1989 until his death in 2001. (Courtesy of Matt Brewing Company.)

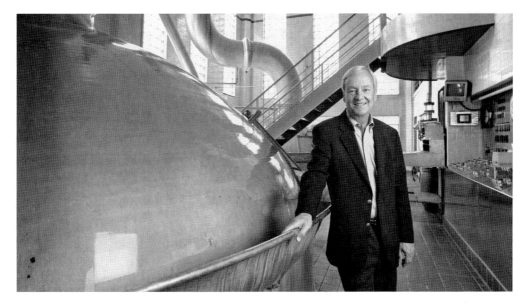

Nick Matt and Saranac

"Craft beer is at its roots innovation," says Nick Matt, who helped purchase the Matt Brewing Company from a trust established upon the death of his grandfather F.X. Matt. A former executive with Proctor & Gamble, Nick Matt returned to the Greater Utica area to assist his brother F.X. Matt II in repositioning the brewery in an increasingly competitive marketplace. When Saranac Adirondack Amber earned a gold medal at the Great American Beer Festival in 1991, Nick Matt guided the company in a bold new direction to become part of what beer enthusiasts would years later call the "craft beer movement." As the brewery celebrates 125 years in brewing in 2013, Matt is especially proud that his family never compromised the craftsmanship in their beer, whether from their own Saranac or Utica Club lines or the many contracts it fulfills for brewers like Brooklyn Brewery. "People make such a difference," Matt says. "Through years of endless economic pressure we have maintained our beer's quality." (Above, photograph by Nancy Ford; below, courtesy of Matt Brewing Company.)

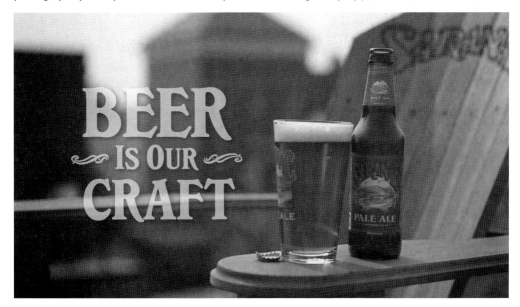

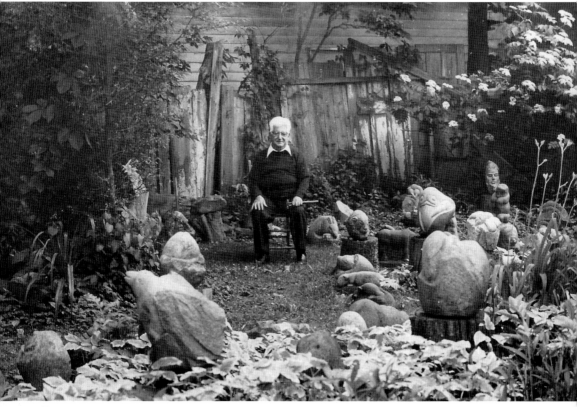

Henry DiSpirito

When daughter and fellow artist Teresa asked Henry DiSpirito (1898–1995) what should become of his many works upon his passing, DiSpirito is said to have remarked, "They're here, and when the time comes you'll know what to do with them, and if not, let them go back to nature from where I got them." DiSpirito's journey as an artist spanned nearly a century; he first studied and practiced as a painter in his native Italy before immigrating to the United States in 1921. It was 20 years later—while applying his trade as a stonemason and bricklayer for the Depression-era Works Progress Administration (WPA)—that he was asked to partake in a WPA artist project and begin sculpting. His daughter Dolores recalls that famous art teacher Richard Davis "knew that my father could easily divert his talents to sculpting because, as a mason, he was already familiar with the tools of the trade. Consider the arc of my father's life when knowing that he conducted art seminars at Colgate University in one of the very buildings he helped build as a brick-layer!" DiSpirito was artist in residence at Utica College of Syracuse University, where he earned a doctor of humane letters degree in 1989. His work has been exhibited in New York's Whitney Museum and the Museum of Modern Art, as well as in the Munson-Williams-Proctor Arts Institute, Utica College, and Cooperstown Fenimore Art Museum. Yet DiSpirito took the greatest pride in sharing his works with his family and city; he curated a sculpture garden in his backyard on Blandina Street that was a marvel to visitors. "He was a man who loved his family and friends, and he demonstrated and lectured in every school in the city," Teresa DiSpirito says. Henry would seldom travel far from home and his work, and only for special occasions, such as a Cooperstown or New York exhibition of his work or a request from Norman Rockwell to visit his Massachusetts studio. DiSpirito is seen above at his East Utica sculpture garden, and on the opposite page, at work on a wooden sculpture, *The Athlete*, which now resides in the Utica College Clark Athletic Center. (Photographs courtesy of Dolores DiSpirito; photograph of the completed *The Athlete* by Ryan Orilio.)

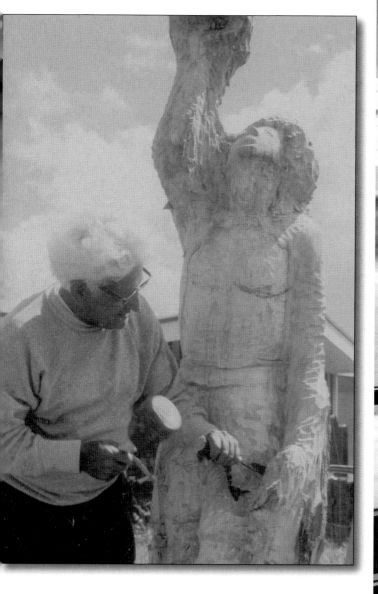

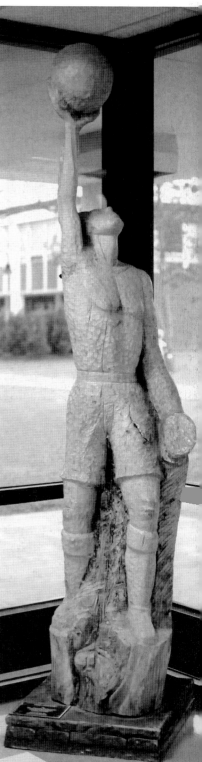

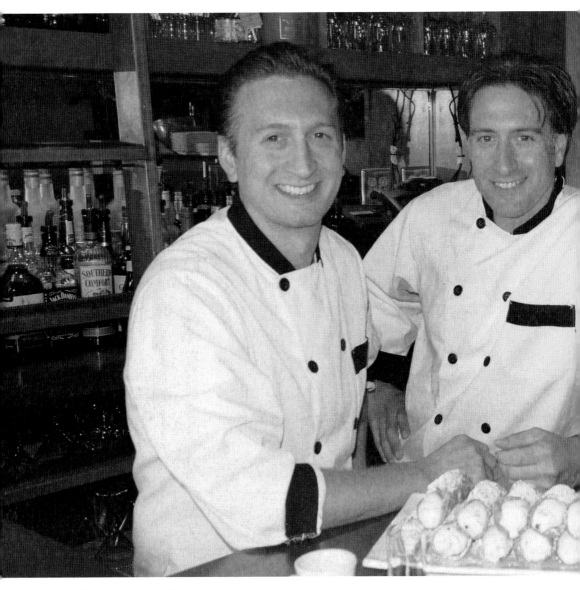

Dean Nole and Jason Nole

World-renowned chefs Dean (right) and Jason (left) Nole call Utica home, and though their talents are in demand coast to coast and around the world, their hearts are in the region's two premier restaurants, Café CaNole and Ancora! To the Nole brothers, it is just natural for two culinary masters and Whitesboro natives to be here because, as any Utican or person lucky enough to dine here knows, no place in the world does food like Utica. The confectionary delights of the Nole brothers' operations orbit around Dean's intense devotion to the art of Italian pastry. A lover of theater and opera and star of Carlo Ventura's 2004 film *Come Away With Me*, Dean earned his world-class training at the Culinary Institute of the Arts, the Gruppo Italianne School in Torino, as well as under the tutelage of Rick Moonen at New York's Water Club. When he is not at Café CaNole, he puts on master classes in pastry making in Italy, Japan, and across the United States. "My biggest influence has been working in Italy and seeing how passionate they are about their craft and how much respect they have for their work. How they take simple ingredients and turn them into masterpieces." Working with Japanese chefs has encouraged Dean

to strive for ideals of discipline and precision in the kitchen. "There is a saying in Sicily," Dean reminds folks when thinking about places like Utica, "*Tutti la monde un paese*: all of the world in just one town." Jason is the mastermind of tapas flair at Ancora!, a restaurant that blends the traditional and the cutting-edge in the heart of downtown. Since 2006, Jason's cuisine has been the perfect culinary centerpiece for the rebirth of the Stanley Performing Arts Center; the restaurant has become a hub of Utica nightlife and is packed beyond capacity on show nights. Jason studied his craft at the Culinary Institute of the Arts and under the tutelage of Chef Todd English at New York's Olives. Matthew Abdoo, a chef de cuisine for celebrity chef Mario Batali at New York's Del Posto restaurant, spent many of his formative years in the Nole kitchens and reminds folks that Jason's work at Ancora! may capture the hipness of the American food scene but is steeped in Italian American tradition. "They have been an amazing influence on my life and culinary career," Abdoo says "and have been a great inspiration to maintain and pass down family traditions of the Utica area." (Courtesy of Dean Nole.)

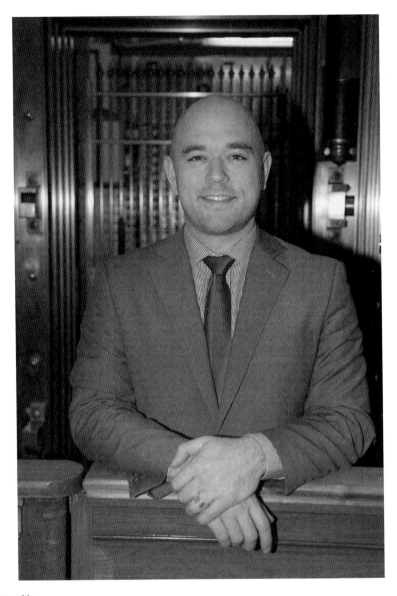

Barry Sinnott

The new face of a venerable Utica institution, Barry Sinnott of the Bank of Utica is as bullish about the region as he appears to be in his bank's popular recent television commercials. "After having spent college years living in Boston and DC, and then living between China and the US for the last 12 years, I am a proud son of Utica and wear Utica on my sleeve," Sinnott rejoices. "I never tell people I meet in large cities I'm from New York; I say I'm from New York State, then when they ask what that means, I am able to tell them about Utica." Sinnott also spends part of his professional life as business development manager of Mayflower Trade, a US-Chinese import/export liaison, and has thus become astute at the art of capturing the essence of a company for unfamiliar audiences. "When Bank of Utica decided to re-brand our bank, we thought about many themes," Sinnott explains. "However being that we are local to the Mohawk Valley, and that we are 100 percent organically grown from the bottom up by the Greater Utica area, we owe everything to the community. And so we decided to brand our bank with just that—a positive image of our community." (Courtesy of Bank of Utica.)

CHAPTER THREE

Voices of the Community

One witnesses the best of this community when Greater Utica raises its collective voice. Take for instance the Boilermaker Road Race, approaching its fifth decade. As race director Tim Reed explains, the success of the race is based on the countless efforts of volunteers and the thousands of spectators who fill the neighborhoods to cheer on runners. As *Runner's World* observed back in 2007, "Seemingly, this city's signature 15K [is] treated as if it were a national holiday." Nevertheless, residents' reasons to celebrate are oftentimes encouraged by individual voices of the community that inspire others to seek purposeful lives and the realization of the best within them.

These voices ask Uticans to investigate, examine, and evaluate their local history in order to appreciate Utica's role in the American experience while also preserving that which makes this area distinct. They also bring remembrances of places and events from around the world that inform lives here. Community leaders such as James Blackshear, among others, spent the better balance of their adult lives giving back to the neighborhoods that they revered. The *Utica Observer-Dispatch* stories and columns by Frank Tomaino, Joe Kelly, and Dave Dudajek chronicled the lives of Utica's unsung heroes, enriching a sense of community. Mother Lavender and Helen Sperling, in their generous and humble manners, have asked that all demonstrate dignity and courage in the face of inhumanity.

The voices of this community have cheered on their neighbors and made each individual feel part of something greater. Like Margaret Sanger, they have modeled what it means to be a volunteer, and like "Doc of Rock" Jerry Kraus, they have spun the records that became a collective soundtrack. Events took on greater importance when Bill Worden reported the news on WKTV and covered the Greatest American Heart Run & Walk.

Perhaps most importantly, these voices also try to cull from the many different dreams and opinions about what the future should hold for this region to craft one message that Greater Utica can get behind.

Mother Lavender

Ellen Elizabeth "Mother" Lavender (1841–1928), an inspirational social leader during the Progressive Era (late 1800s–early 1900s), was known throughout the city for her charitable works and profound sense of social justice. Her life's mission was inspired by years enslaved on plantations in South Carolina and Georgia. During the Reconstruction era, Lavender traveled to the Northeast in search of new opportunities; there, she married, raised a small family, and discovered her penchant for public speaking. Locally, she became a notable advocate for the increasing number of the working poor in industrial cities, like Utica, throughout the Northeast. Her inspirational story is the subject of a book for young readers, *The Story of Mother Lavender*, written in 2007 by Uzo Unobagha and illustrated by Alba Scott. This piece, by Robert Cimbalo, depicts one of Lavender's annual New Year's Day feasts for the less fortunate. (Courtesy of Robert Cimbalo.)

Justus Henry Rathbone

An awe-inspiring funeral monument overlooking Utica from Forest Hill Cemetery memorializes Utica native Justus Henry Rathbone (1839–1889). He is best remembered as the founder of the Knights of Pythias, a fraternal order not unlike the many social and service organizations thriving in the mid-1800s. Inspired by the Greek legend of Damon and Pythias, which focuses on tests to the ties of friendship, the order was established in 1864 in Washington, DC, while Rathbone worked as a federal employee. "If fraternal love held all men bound," Rathbone argued, "how beautiful this world would be." The society, still active throughout the United States, was the first such organization to be chartered by the US Congress, followed soon thereafter by the Boy Scouts of America. (Right, courtesy of Library of Congress; below, photograph by Ryan Orilio.)

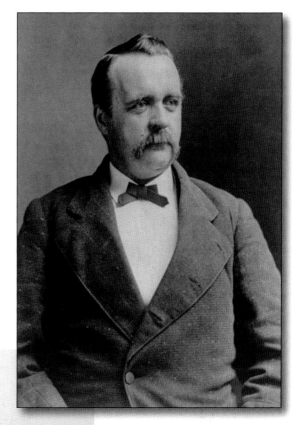

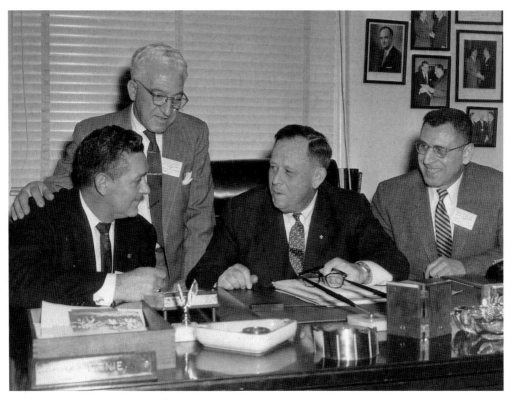

Alexander Pirnie

Alexander Pirnie (1903–1982), pictured in the center, is the namesake of the Pirnie Federal Office building in downtown Utica (below). He represented the 34th Congressional District, then the 32nd, as a member of the US House of Representatives from 1959 to 1972. Before serving as an officer in World War II and earning the rank of colonel, Pirnie studied law at Cornell, graduating in 1926. The photograph above was taken in 1961 during a meeting at his Utica office to discuss legislative matters pertaining to the extension of benefits for his fellow World War II veterans. To the far left is local American Legion commander (and the author's grandfather) James Davis Sr.; also pictured are fellow Legionnaires. (Above, courtesy of Davis Archives; below, photograph by Ryan Orilio.)

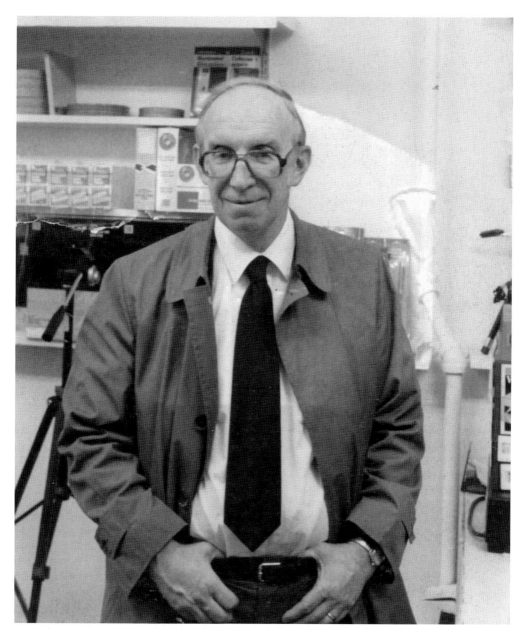

Ronald Campion

Local historian and writer Joe Bottini says of Ronald Campion "I feel that his name was misspelled. The second letter in his surname should have been an *h* for Ron was a 'Champion.'" Campion (1930–2012) taught high school in Chadwicks and Utica before becoming dean of students and director of financial aid at Utica College (1960–1965). It is for his time there that he is remembered as a tireless advocate for students, most notably in his support for fellow veterans of the armed services that were enrolled at the college. Campion left academia to pursue work in the real estate realm, where he was a leader for nearly five decades. He was a dedicated public servant, acting as a member of the Greater Utica Board of Realtors, New York State Society of Real Estate Appraisers, and the Newman Foundation at Utica College. (Courtesy of the Campion family.)

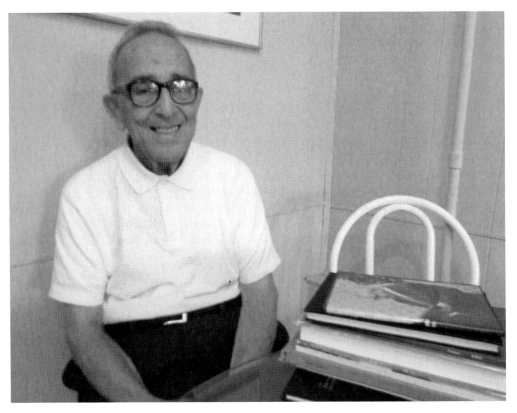

Eugene Paul Nassar

It is hard not to see Eugene Paul Nassar bound to Utica in much the same way Dante, whom he has studied extensively, was tied to his beloved Florence. Nassar is the very epitome of the public intellectual in Greater Utica, and his years of teaching at Hamilton and Utica Colleges, numerous books, and countless newspaper columns have been a treasured resource for nearly half a century. Though he credits his brother with first introducing him to the world of literature, a world in which Nassar would live for decades as an internationally renowned literary critic, he also argues that it was his Oxford tutor, Christopher Ricks, who inspired an even greater passion for reading, writing, and critical thinking. "Studying with Ricks was the most fortunate experience I ever had," Nassar argues as he thinks back on his time as a Rhodes Scholar, a few years before earning his doctoral degree at Cornell University. Ricks stayed at Oxford, and went on to perhaps the most prestigious post in all academe—professor of poetry—a post he held from 2004 until 2009. Yet Nassar knew that his academic life needed to be closer to home, teaching college students who were like he had once been: driven, enthusiastic, and bright children of humble immigrant families for whom a college education was a great blessing. "I walk my neighborhood surrounded by the presences of these immigrants," Nassar remembers in his part-memoir, part-literary critique *A Walk Around the Block*. "Friends, relatives and family, many long gone, who gave these streets and home vitality for me." In his work, Nassar suggests that the context one brings to literature has a subconscious quality to it "which is partially a dream . . . I have, however been very lucky in the dreams in which I have found my own self-definition, and in the social context of family and place in which I have been privileged to live." Nassar is still busy writing in East Utica, occasionally stops in for a pastry at the Florentine (as pictured above), and regularly contributes to the Utica College Ethnic Heritage Center, which he founded. (Photograph by J. Davis.)

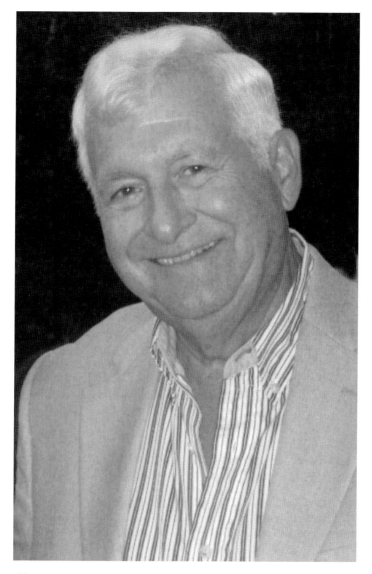

Malio Cardarelli

No one has captured the spirit of Utica neighborhoods as Malio Cardarelli has in his 17 books on local social history during the 1950s. Each work is a reflection on the important social concerns of the day, exploring how and where Uticans worshipped, shopped, made their livings, and celebrated and preserved their cultural heritage. A Proctor High School and Utica College graduate, Cardarelli spent much of his professional life in the field of public and personnel relations, retiring from Griffiss Air Force Base after more than three decades, some of which was spent leading the civilian personnel management department. In order to compose the next chapter of his life, Cardarelli explains, "I returned to my earlier writing passion, deciding to expend my efforts on preserving the people and events that made the mid-20th century in Utica so remarkably interesting, and enjoyable." It is tempting to ask Cardarelli what a future version of himself will find captivating about Utica life. "Some future writer may focus on the joys of shopping malls, the wonders of the ever-expanding electronic age, or other types of events that made their youth so special," Cardarelli explains, "that time in life when worries are few, financial concerns minimal, and the need to be competitive something yet to come." (Courtesy of Malio Cardarelli.)

Michael J. Bosak

Michael Bosak, renowned architect and past president of the Utica Landmarks Society, has spent a lifetime envisioning new structures while trying to preserve the best of what is left of Utica's fading architectural golden age. Perhaps because of his passion for the architectural gems, Bosak is one of the many successful professionals looking for a winning formula for the future of the city. "The key is our ability to adapt, to accept new cultures and people," Bosak suggests, and to, "grow while shrinking." Still active as a state architect for the federal government, Bosak has been a leader in a number of municipal organizations and tourism ventures such as the Adirondack Scenic Railroad, the local chapter of the National Railway Historical Society, as well as a noted expert on Utica Landmarks such as "Old Main," Munn Castle, and the Miller-Conkling-Kernan House in the historic corridor of Rutger Street. (Photograph by J.P. Bottini.)

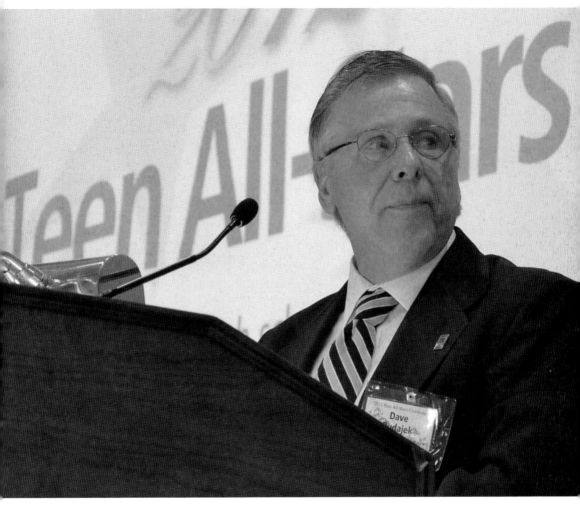

Dave Dudajek

Dave Dudajek has been informing people about the life and times of Greater Utica since he was hired as a copy editor at the *Observer-Dispatch* in 1979. He has helped shape public discussion in the region as opinion-page editor beginning in the late 1990s, a forum that Dudajek says continues to live up to its mission of being "a catalyst for positive change" because "it's important to generate public discussion on community issues, and the time-tested way to do that is through the opinion pages." The many columns he has written over the decades have focused on families, friends, and Utica community life, and Dudajek sincerely believes that the region is "truly blessed with the best people to be found anywhere." Local readers also know Dudajek for his work on two ongoing projects at the paper. More than 20 years ago, he was selected by the newspaper's editor to spearhead an annual "Teen-All Star" news feature trumpeting the accomplishments of local high school graduates. He also has written a number of pieces in conjunction with the newspaper's support of Operation Sunshine (a nonprofit venture that sponsors deserving children to attend summer camp) and a toy, food, and clothing drive for families during the holiday and winter months. A native of New York Mills and graduate of Utica College, Dudajek says that he "never felt any reason or any desire to leave," the Utica area, and has "absolutely no regrets about that." (Courtesy of the Utica *Observer-Dispatch*.)

Frank Tomaino

Frank Tomaino grew up in East Utica in the 1940s, served in the Air Force during the Korean War, and attended Utica College on the GI Bill. While majoring in English, he also worked as a stringer sports reporter for the *Observer-Dispatch* (*O-D*) and, a year after graduating from college, landed his first full-time job at the paper in 1962. After a brief time in the classroom, Tomaino returned to the *O-D* as reporter and rose to city editor in 1968. As city editor, he began a long-running column, "Frankly Speaking," devoted to local history topics, and when the *O-D* joined forces with its sister paper, the *Daily Press*, his column ran under the heading "This Week in History," which Tomaino still contributes in his retirement. As *Observer-Dispatch* opinion editor Dave Dudajek puts it "Frank officially retired from the *Observer-Dispatch* some years ago, but fortunately, he never left . . . He's a real gem and we're not likely to see anyone like him again." (Courtesy of Carl Saparito.)

Ray Durso
Ray Durso, executive director of the Genesis Group, grew up in East Utica during the 1960s and 1970s and has spent almost the last dozen years developing a new model for community activism. At once blending the best attributes of Rotary International, the Kiwanis Club, and chambers of commerce, the Genesis Group has made Utica a nexus for regional volunteerism and economic revitalization. Durso sees the area as "priming itself for a major economic transformation," something that will depend on a high-technology future and willingness of the region to work cooperatively as a whole. Durso encourages everyone he works with throughout the region to be ambassadors for the quality of life to be found in Utica, and he is certain that when Utica's next chapter is written, the "transformation will certainly affect our quality of life—in a positive way." (Courtesy of Ray Durso.)

Command Master Chief Mark R. Williamson
Graduating from Utica Free Academy in 1984, Mark R. Williamson began a career in military leadership that has spanned more than two decades. His US naval career began as a deck seaman on the USS *Oakridge*, but the success he earned as a corpsman put him on a path of medical-service leadership in major campaigns, including Desert Storm, Operation Allied Force/Noble Anvil in Kosovo, and Operation Iraqi Freedom. Though retiring as command master chief in 2007, he is readily recognized in the city as the director of the junior ROTC program for the US Navy at Proctor High School, where he espouses the virtues of honor, dedication, and service. (Courtesy of Command Master Chief Williamson.)

Frank B. DuRoss

Frank DuRoss grew up on Utica's east side as part of a business-oriented family, his own ambitions eventually taking him across the state and around the Northeast in pursuit of professional-sport and real estate ventures. His entrepreneurial success has stemmed from his ability to build coalitions between politicians, sports investors, and the community at large. "My role has always been defining 'the big picture,' and then answering the question 'How do I get there?'" DuRoss explains in his Mohawk Valley Community College offices, where he currently serves as executive director of institutional advancement. DuRoss was once chief executive of the Utica Devils Hockey Team and president and majority owner of the Providence Bruins Hockey Team, and he established two major league sports team in Rochester, New York: the Rochester Raging Rhinos Soccer Club and the Rochester Rattlers Lacrosse Team (part of a league DuRoss helped form). Always bullish about the abilities of his hometown, DuRoss continues to work with various regional stakeholders to market Utica's comparative advantages and educational opportunities, most recently with a group establishing the Utica Comets AHL hockey team. (Courtesy of Frank DuRoss; photograph by MVCC.)

Robert Holmes

Robert "Bobby" Holmes (seen here in his US Army photograph from the late 1950s) has carried on a family tradition of public service that began with his father, Everett Holmes, who, as mayor of Bridgewater, was the first African American mayor to serve in New York State. While working a full-time job for United Parcel Service, Bobby Holmes dedicated his free time as a drug counselor and civic leader, first as the leader of the Youth Outreach Group, and later as an advisor at Mohawk Valley Community College (MVCC), Utica City School District, Utica Municipal Housing Authority, and the Oneida County Youth Bureau. Speaking to students and youth groups and working with elected officials to curb the nefarious influence of drugs and violence in the community, Holmes became a trusted ally among educators and law enforcement officials. His credibility and motivation stemmed not only from his deep dedication to helping others but also from the fact that drugs had adversely affected his own family. Holmes credits his wife, Eleanor, and her leadership at home in enabling him to make a positive impact on his region. "She has been behind me 110 percent. Without her blessing, and taking on more of the family responsibilities, I could not have done it." Upon learning of Holmes's recent health ailments, Utica City historian and teacher Lou Parotta stated in a letter to the *Observer-Dispatch*, "Amazing how a man who always speaks from the heart has a heart that is hurting. It must truly be from overuse." (Courtesy of Robert Holmes.)

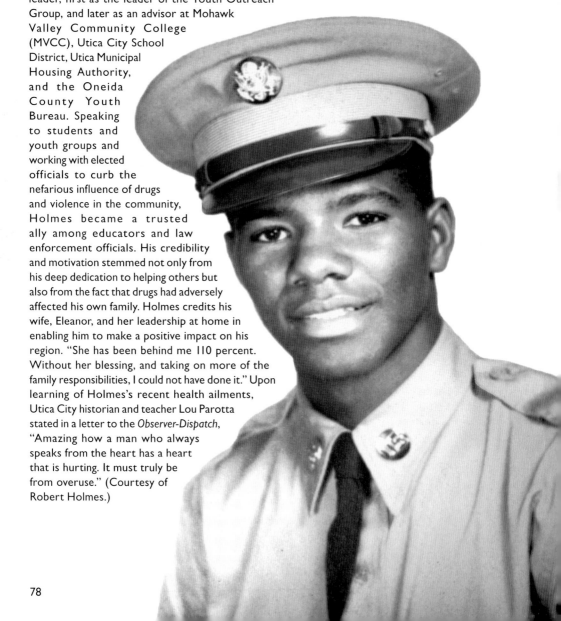

Ralph Leo
Ralph Leo has been an educator for nearly 45 years in Utica schools, serving as a special education teacher, attendance officer, and longtime varsity basketball coach for Proctor High School. He is widely recognized around the region for his weekly high school basketball feature, "Around the Rim," which runs throughout the winter and predicts the outcomes of marquee high school basketball games in addition to providing brief tutorials on basketball fundamentals. Leo, however, mostly thinks of himself as a devoted family man who tries to provide an equal amount of commitment to helping Utica children reach school everyday. "That is part of my job," Leo says. "Keep them in school and try to convince them of their worth and capability. The hope is we reach a few of them." (Photograph by J.P. Bottini.)

Helen Sperling

"If nothing else is accomplished," Helen Sperling says of the two hours she spends with an audience, "it is enough that people are kind to one another, and are not bystanders." Sperling hopes that the thousands of students, prisoners, law enforcement officials, and faith communities she has met during the past 45 years of sharing her story as a Holocaust survivor know that "though my nights always belong to Hitler, when I wake up from my dreams, those students, those people, they are there standing up for me." Sperling gives paramount credit to her audiences for internalizing her message "that we need to see the world through one another's eyes, and know that we are not alone in the world." She is inspired by the countless letters of hope and peace she has received over the years, such as the birthday card pictured here, written in her native Polish and sent by students from nearby Holland Patent Central School. "I know that when children leave one of my talks, they walk away knowing that they count, that they are somebody who matters, and won't live life as a bystander." (Photograph by J. Davis.)

William S. Calli Sr.
William S. Calli Sr. (1923–2012) of the law firm Calli & Calli (later, Calli, Calli & Cully) practiced law in Greater Utica area for more than six decades while maintaining a distinguished record in public service. While his most recent public role—that of general council for the city municipal housing authority—allowed him to concentrate his efforts mostly on the city, Calli spent decades (1950–1980) representing the region in Albany, first in the state assembly and then in the state senate. He also served as Oneida County attorney from 1980 until 1993. Upon his passing, Oneida County Bar Association president Elizabeth Snyder Fortino told the *Observer-Dispatch* that Calli "had his hands in everything to help make the Mohawk Valley a stronger place, not only for his family and his generation, but for generations to come. He really was integral to the foundation of so many things that are thriving in the community today." (Courtesy of Robert Calli.)

Marie Russo

Though all analogies are imperfect, Marie Russo may be considered the Jane Addams of Utica. Both women enriched the lives of immigrant families by directing settlement houses, but Russo, unlike Addams, was a direct beneficiary of Utica's Italian Settlement House—renamed the Neighborhood Center in 1945—as a first-generation American. As she grew up, she became more involved in settlement-house management and community service, directing playground activities there as a teen. Russo studied at Morningside College in the Midwest and as a graduate student at Columbia University's School of Social Work; her professional life led her somewhat to the geographic middle between the two, back to her beloved Neighborhood Center. While at the Neighborhood Center, Russo was named social worker of the year, the Utica *Observer-Dispatch* Boss of the Year in 1996, and an honorary doctor of humanities at her alma mater. She directed the Neighborhood Center, which still operates on Mary Street, from 1967 until 2001. (Courtesy of OCHS.)

Margaret Ford of the Stevens-Swan Humane Society
For more than a century, the Steven-Swan Humane Society of Oneida County has been a Utica refuge for animals in need of shelter. It has also been a source of great pride for a region striving to maintain an ethical treatment of animals as envisioned by its founders, James Stevens, Gustavas Swan, and William Blaikie. The shelter's success hinges on public awareness, financial donations, and volunteer efforts. As to the latter, there is perhaps no more dedicated volunteer than Margaret Ford of Whitesboro, who has devoted 69 years of volunteering, saving by her own count an estimated 200 dogs in the process. Former Stevens-Swan public relations director Jerry Kraus says "It's amazing to see her friendly personality and diligent work ethic week after week for so many years. Margaret reminds us about how important our volunteers are to the shelter operations and how we all need to give back to help make our community a better place to live. She is a true unsung hero of our shelter." (Courtesy of Jerry Kraus.)

St. Marianne Cope
St. Marianne Cope (1838–1918) began her spiritual journey as worshipper at St. Joseph's Church during the mid-1800s. A German native, she would have an impact on each American community she settled in throughout her life of service. She was instrumental in establishing St. Elizabeth Hospital in Utica, and the Westside Kitchen at St. Joseph–St. Patrick's Church on the corner of Columbia and Varick Streets now bears her name. She lived in Syracuse as a sister of St. Francis for much of her early adulthood but spent the last half of her life tending to leprosy sufferers in Hawaii. She was canonized on October 21, 2012, by Pope Benedict XVI. (Photograph by J. Davis.)

John Harrison

John Harrison's community leadership began upon his 1967 return from the Vietnam War, where he was awarded the Purple Heart as a US Army paratrooper. Harrison served as a Utica fireman for 20 years, earned several degrees from Utica College and Syracuse University, and became a social service counselor. As commander and cochairman of the Military Order of the Purple Heart Chapter 490, he was instrumental in the erection of the Vietnam War Monument on Utica's Memorial Parkway and Holland Avenue in 1985. A respected voice on issues of race, Harrison lectures about a life trajectory that began as a migrant worker in the American South and has passed through several eras of racial prejudice and reconciliation. "The real value of Utica and this region is it is full of a lot of history going back to the founding of the nation, Harrison says, "veterans, politicians, common folks all are involved in the history of this area." (Right, courtesy of John Harrison; below, photograph by J.P. Bottini.)

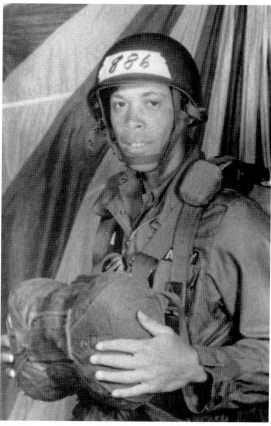

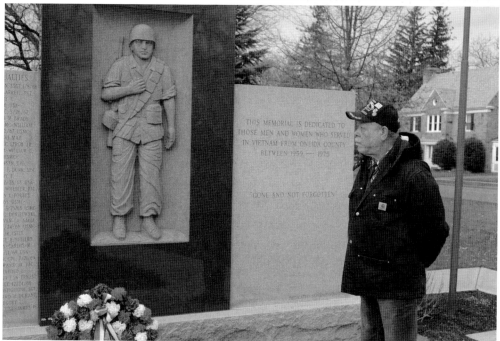

Jerry Kraus

Better known as "the Doctor" and "the Doc of Rock," Jerry Kraus grew up on the west side border between Utica and Yorkville during the 1960s and early 1970s and emerged from college at SUNY Oswego looking for a job back home. That search eventually landed him at the Oneida County Finance Department in 1978, and soon thereafter at WOUR, a Utica-based rock-and-roll station, at a moment in American history when FM, rock, and album-oriented music were reflective of baby-boomer values. WOUR was unquestionably the station of choice for teenagers in the 1970s and 1980s, and "the Doctor" Jerry Kraus was the deejay that mattered most in Utica during a time when deejays mattered. "We were the place to get the best music plus information about club and concert happenings and the latest news and community updates. We were the one radio station for all of it," Kraus recalls. "People met and got married at our parties, we were their 'lifestyle' station, we sold—and gave away—tons of T-shirts and people flocked to our events. Listeners loved us and we loved them. We were there right along with our audience age-wise so we knew exactly what 'we' were interested in, and we delivered." The Doc of Rock still delivers through his countless community efforts, including a term on the City of Utica Common Council, the past five years as public relations director for the Stevens-Swan Humane Society, and leadership roles at the United Way, Utica Independent Softball League, the Utica Boilermaker, and Stanley Theater Board. Kraus returned to radio after 30 years at WOUR to host "The Recovery Room," a multi-hour weekend radio show on 92.7 the DRIVE featuring the album-oriented rock that made deejays like the Doc trailblazers just a generation ago. Kraus was named executive director of the Stanley Theater in the summer of 2013. (Courtesy of Jerry Kraus.)

Bill Worden

Bill Worden is synonymous with news in the Utica area. He remains a household name since taking the job as news anchor at WKTV News Channel 2 in the late 1970s, which he filled until late 2012. As with many Mohawk Valley natives, Worden explored several other regions before permanently establishing himself back home. He served in the US Air Force in the early 1960s, was a pioneering radio personality at both MVCC and Utica College, and worked as a broadcast journalist in Kansas and Ohio. A noted musician, an American Legion leader, and a popular keynote speaker, Worden has earned numerous industry awards for his work at WKTV and has been recognized for numerous philanthropic efforts. (Courtesy of WKTV.)

Donna Donovan

Readers of Donna Donovan's neighborhood newspaper in Jersey City, New Jersey, would have had very little trouble predicting where her professional life would take her. After all, at merely 10 years of age, Donovan was part of a team that published a newspaper for her block. A journalism major in college, she wrote her first stories for regional media outlets in her home state until a chance to become the executive editor of the *Utica Daily Press* and *Observer-Dispatch* brought her to the Mohawk Valley. Her success in Utica resulted in jobs as president and publisher in South Dakota and Burlington, Vermont, where she also supervised several newspapers in the Northeast as a regional vice president for Gannett Company. She and her husband, Jerry (see page 2), were enthusiastic about the chance to move back to Utica when Donna returned to the *Observer-Dispatch* as publisher. "The people here are absolutely outstanding: generous, giving of time and money, open to new cultures and approaches," Donovan says. "I think our openness to new cultures is an enduring quality, and will bring many new, exciting changes in our community moving forward. This community also has a deep spiritual core, and a respect for the many different paths to God." Donovan is particularly proud of her newspaper's leadership role in the community as a large employer, major sponsor of the Boilermaker and the United Way, and patron of the arts. Of her 125-person staff, Donovan says, "We want to be a catalyst for positive change—through news coverage, through community service. We are a vital part of our community, just as the *Observer-Dispatch* is a vital part of our community." (Courtesy of the Utica *Observer-Dispatch*.)

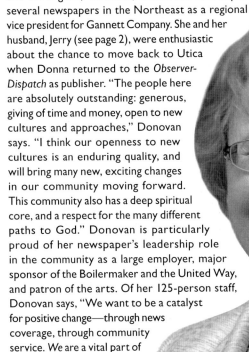

Joe Kelly

Joe Kelly has been a major name in local media for decades, as a celebrated *Observer-Dispatch* columnist, newspaper publisher, and host of WUTR's local-interest talk show. Kelly has written newspaper columns for the last 30 years, or, as Kelly admits in the title of one of his seven books, *I've Been Writing A Newspaper Column For So Long I Don't Think I Could Hold A Real Job Anymore.* He was the *Observer-Dispatch*'s first full-time columnist and went on to write a weekly column for the *Boonville Herald*, where he has been publisher since 2001. Kelly continues to demonstrate his passion for all things Utica on *The Joe Kelly Show*, inviting numerous leaders, artists, authors, and community volunteers to share their local contributions with a devoted audience since 1998. (Photograph by J.P. Bottini.)

David Mathis
The ideal of creating educational opportunities for students in the Greater Utica area has fueled the work of David Mathis for all of his professional life, especially in his role as executive director of the Oneida County Workforce Development Program. Mathis has devoted much of his time and energy to building bridges between the region's colleges and lower-income students, and his leadership has been particularly important in helping to define the role of Mohawk Valley Community College as both a catalyst for economic progress and as a destination for Utica-area students. The recipient of numerous awards—including outstanding service and achievement awards from the Salvation Army, United Way, and Utica College—he holds the distinction of being the first MVCC alumnus to serve as college trustee and chairman of the board of trustees. An Oneida County NAACP Lifetime Achievement Award winner, Mathis is currently focusing on policies to bolster community college graduation rates. (Courtesy of David Mathis.)

James Blackshear
James Blackshear (1950–2000) "gave to the community to the last minute of his life," says longtime friend and Oneida County Workforce executive director David Mathis. Blackshear occupied a prominent role in Utica social life as the executive director of the Utica Cosmopolitan Center for almost a generation. He grew up in the city and attended college at the Utica School of Commerce and, later, SUNY Institute of Technology. Blackshear earned numerous awards for his community service, including the inaugural Martin Luther King Award, bestowed on him by the Mohawk Valley Frontiersman, and the Len Wilber Award for Community Service from the Utica Kiwanis Club, where Blackshear once served as president. Upon his death in 2000 at the age of 50, the Kiwanis Club renamed the Len Wilber award the Wilber-Blackshear Memorial Award. Dozens of community members gather annually to commemorate Blackshear's positive contributions to the region at a memorial prayer luncheon sponsored by the Kiwanis Club and the Hope Chapel AME Zion Church, where Blackshear was a lifelong member and former chief financial officer. (Courtesy of David Mathis.)

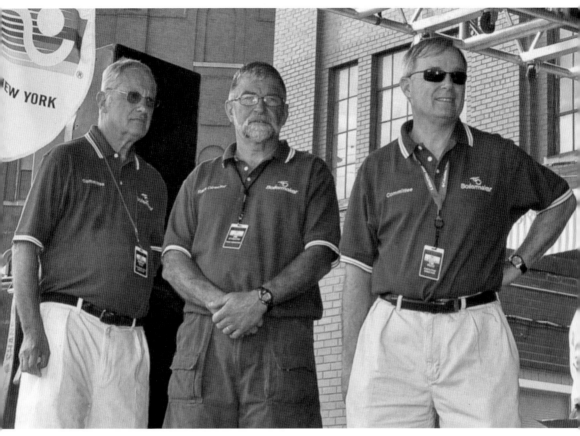

Earle and Tim Reed

Earle Reed (left) started the Boilermaker Road Race in 1978 from the offices of then Utica Radiator Company (also known as "Utica Boilers") on Dwyer Avenue and continued for another nine and three-tenths miles. Years later, the Boilermaker Road Race would grow into an international sporting event, regularly drawing more than 10,000 runners and three times as many revelers to the F.X. Matt Brewing Company's post-race party. Reed oversaw operations at Utica Radiator for a number of years, continued to be active in the planning and operation of the Boilermaker, and served as town supervisor for New Hartford from 2005 to 2009. Tim Reed (right) has been the executive director of the Boilermaker for the last five years following a career that took him from life as an airborne ranger in the US Army to business executive at ECR International. Asked about the continual success of the race, Reed says, "The real key to success is to get highly motivated people and get out of their way. My vision for this race has been to make it a change agent for this community for both the economic and physical health of the community. I was taught by my parents at a very early age the importance of community service and leaving the place a little better than when you came." Jim Stasaitis, center, is the current Boilermaker Race director. (Courtesy of Mary McEnroe.)

CHAPTER FOUR

Beloved Personalities

Regarding the celebrated people from around town that are often read about or seen on television, it can be great to know why they are so committed to sharing their time and talents with Greater Utica. Their sense of values and dedication to community involvement often spurs others to be similarly focused. Their musical performances, sculptures, paintings, feats on the field of play, and athletic teams have enriched the lives of many locals. Their names—such as Frye and Edick—adorn schools and athletic fields, providing sturdy reminders of their legacies.

Local artists' work has served many functions, among them the preservation of the region's heritage. Whether in paintings by Robert Cimbalo or sculptures by Henry DiSpirito, the lives of Uticans ordinary, and extraordinary, have been captured for generations to consider and admire.

Many of the beloved personalities that have made the Greater Utica area special have not made the front page of the newspaper or been seen regularly, if at all, on local television. Instead, these are the folks that one runs into every day at the bakery or at school, those who, in subtle ways, shape the lives of others. Uticans see these folks—such as barber Leo Gilman—so often that it is easy to take for granted how they help define life here; many, in fact, have significant and fascinating chapters in their lives that they do not widely share but that define their daily interactions and the missions in their lives. Others have been witnesses to history, and to know them means that one can be a witness to such turning points as well. Just as important as the voices in the community who share their wide-ranging experiences with large audiences, the stories told by folks like Johnny Scarfo and Frank Bergmann can, in smaller settings, be just as impactful.

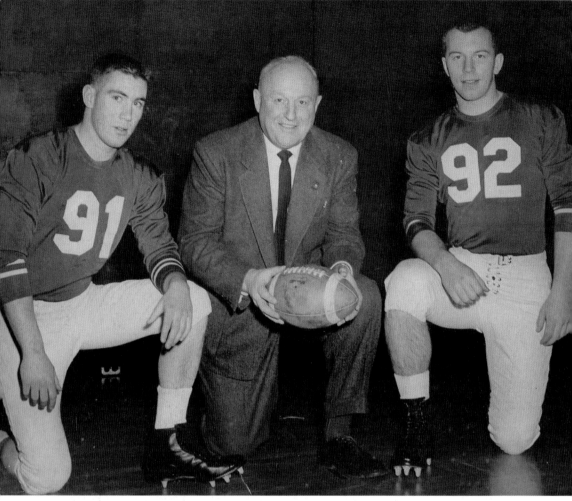

Allen "Chiz" Frye

Allen "Chiz" Frye (1908–1968) was a standout athlete at both Brownville-Glen Park High School (outside Watertown, New York) and Central New York's Manlius Academy; he later went on to play football, basketball (serving as team captain), and baseball at SUNY Cortland. Chiz became one of the most respected scholastic coaches in the Utica area, coaching at Whitesboro High for the better part of four decades (1930s–1960s) the same sports in which he had excelled as a youth. The football stadium at the old Whitesboro High School honors him, as he is credited with promoting football as a high school–caliber sport in the first part of the 20th century. New Hartford coach Don Edick recalls that coaches from across the state emulated Frye. "He was one of the most intense and dedicated coaches around, and he was the kind of coach that every parent would be proud to have their child be coached by. He was an absolute legend." Frye is an inductee of the Utica College, Notre Dame, Whitesboro Alumni, and SUNY Cortland Halls of Fame. (Courtesy of Richard Frye.)

Dorothy Frye
Dorothy (Ryan) Frye met her husband, Allen "Chiz" Frye, while at Cortland State and married him soon thereafter in 1932. She is remembered as a pioneering leader in women's scholastic athletics, coaching women's teams at Whitesboro High School long before women's athletics were common. With aplomb, Dorothy devoted equal time to her roles as a physical education teacher, coach, and mother and was also dedicated to Chiz's coaching success. The official program commemorating the dedication of Frye Field at Whitesboro High in 1973 notes that Dorothy was "the number one supporter of Frye-coached teams in both good years and those not so good, her interest and vast knowledge of sports enable her to fully appreciate the tasks of both athletes and coaches." (Courtesy of Richard Frye.)

Don Edick

"Discipline has been at the heart of everything I have done in my life," says legendary high school football coach Don Edick. From a humble upbringing in Rome, New York, Edick enlisted in the Marine Corps in 1951 amidst the Korean Crisis and, upon returning home, took the mental and physical skills he learned as a Marine to earn a full scholarship to the University of Dayton. At Dayton, he earned a spot on the football team as a walk-on, playing guard and defensive end despite the fact that he was a 25-year-old freshman. Returning to the Mohawk Valley once again, he set out on a career in scholastic athletics that continues to this day, most notably on WKTV's *Coach's Corner*, where he has used his 38 years of coaching experience to survey high school football action for the two decades since his retirement from New Hartford. Though the football field already bore his name, the multisport stadium at New Hartford Central School was dedicated to Edick in the fall of 2009, a fitting tribute given that Edick was a multisport athlete at Rome Free Academy in the late 1940s, playing baseball, football, basketball, and running the mile in track. Though Coach Edick admits that he would be hard-pressed to ever choose a favorite athlete among those he has coached, he is quick to single out the sort of players he wishes scholastic athletes today would emulate. "The Manning boys, both Peyton and Eli. They were clearly brought up right, they play the game with respect, they obviously have a sense of humor, and they show kids that they love to play the game." (Courtesy of Don Edick.)

The Utica Blue Sox

Generations of baseball fans from the Greater Utica area were treated to the magic of live baseball on a warm summer's evening at Donovan Stadium at Murnane Field on Sunset Avenue—or old McConnell Field before that—where the Utica Blue Sox minor-league team played for more than half a century. Countless players would go on to professional baseball careers after stints with the Blue Sox (first in the Eastern League and later, the New York–Penn League), including many of the Philadelphia WhizKids of late-1940s fame (like Richie Ashburn) and 2012 American League Triple Crown winner Miguel Cabrera. The Blue Sox were last affiliated with the Florida Marlins before baseball legend Cal Ripken Jr. helped buy and relocate the team to Aberdeen, Maryland. Noted sportswriter Roger Kahn crafted a memoir, *Good Enough to Dream* (1985), recounting the summer of 1983 when he stitched together a group of free-agent minor leaguers to fill out the Blue Sox roster and win the league championship. (Photograph by Ryan Orilio.)

Mike Griffin

Mike Griffin (1865–1908) was one of the first Uticans to play professional baseball as nationwide leagues began to coalesce. He played from 1887 until 1899 and had many standout years for teams in Baltimore and Brooklyn. His record of 94 steals in his rookie season of 1887 would not be bested until Vince Coleman stole 130 bags in his rookie year for the St. Louis Cardinals. (Courtesy of National Baseball Hall of Fame Library.)

Bob Ingalls

A running enthusiast, Bob Ingalls (1942–2008) was director of the Boilermaker Road Race from 2001 to 2007, a period of significant growth for the race. A former president of the area's largest running club—the Utica Road Runners—Ingalls was a law enforcement official for Oneida County, once serving as undersheriff, as well as an advisor to the county executive. (Courtesy of Mary McEnroe.)

Andy Van Slyke

The St. Louis Cardinals drafted Andy Van Slyke in 1979 after Van Slyke posted one of the most memorable high school athletic careers in local history. "Probably as gifted an athlete that has ever come through New Hartford," recalls Leo Fadel, a now retired New Hartford teacher and the school's Andy Van Slyke Baseball Card and Fan Club advisor. Van Slyke played varsity basketball and baseball and was a teammate of future Cincinnati Reds pitcher Tom Browning on the Clonan Post Legion baseball team in Chadwicks. He built a remarkable major-league career as a Cardinal and as a Pittsburgh Pirate, winning two Silver Slugger Awards, appearing in three All-Star games, and earning the distinction of best defensive centerfielder of his era with five Gold Gloves in a row starting in 1988, the year he was named *Sporting News Magazine*'s Player of the Year. Following several years of coaching professional teams, Van Slyke now contributes to St. Louis sports radio and writes sports-themed novels for young audiences, such as *The Cubs Win! The Cubs Win! Or Do They?* (written with Rob Rains and published in 2010 by Ascend Books). Though he played for teams that were natural rivals to the perennially losing Cubs, Van Slyke was drawn to their mythology and, as he told the *New York Times* in 2010, "I don't think there's anything like it in baseball—people feeling as passionate as they do about the Cubs." (Courtesy of the Utica *Observer-Dispatch*.)

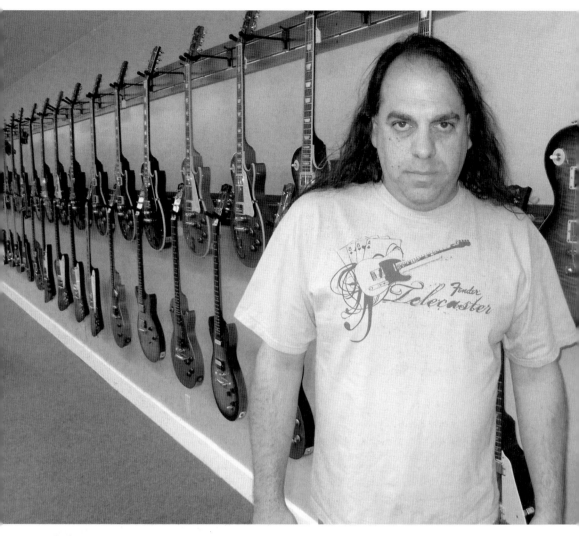

Bob Acquaviva

A Grammy-nominated producer as well as a singer-songwriter, Bob Acquaviva was a pioneering heavy metal musician in the Central New York area during the early 1980s, when the genre was still in its adolescence. Acquaviva was leader of the heavy metal band Luftwaffe for a number of years before forming acts like Mere Mortals, who received radio play and made an appearance on the nationally syndicated show *Dance Party USA*. The engineer or producer of more than 300 recordings, Acquaviva established Acqrok Studios in the late 1980s, recording the likes of Boston and Blue Oyster Cult and earning a Grammy nomination for Boston's 2002 album, *Corporate America*. He toured as technical consultant throughout the 1990s with bands such as Megadeth and Rage Against the Machine and, in the late 1990s, went back to performing with the Big Krush, a group that has recorded four albums and still performs today. Considered by many as the foremost local expert in musical instruments, he currently co-owns and operates Bonamassa Guitars in New Hartford. (Photograph by J. Davis.)

Pasquale "Pat" Santacroce
Singer and teacher Pasquale "Pat" Santacroce was a runaway from an Upstate orphanage who adopted Utica as his home in 1949. He spent years on the road as a teenager singing in bands and seeking migrant work. Santacroce is best remembered as a member of the Trinkas Manor Trio, a vocalist for the Lawrence Luizzi Band, and as a polio survivor and advocate for special education students in the Utica School District. (Courtesy of Pat Santacroce.)

Martin Brodeur
Arguably the greatest goalie in professional ice hockey history, Martin Brodeur spent most of his first year minding net for the Utica Devils before being called up permanently to the National Hockey League (NHL) as a New Jersey Devil. Few Uticans may have guessed that the Canadian-born rookie goaltender of the 1992 Devils season would go on to become the winningest goalkeeper in NHL history (669 and counting) and see his name etched on the Stanley Cup three times. Brodeur is a two-time Olympic gold medalist and has recently initiated the Martin Brodeur "MB30" foundation for charitable causes. (Author's collection.)

Herb Brooks

One of the many "Brooksisms" that Disney's 2004 film *Miracle* employs to immortalize one-of-kind hockey coach Herb Brooks (1937–2003) is his memorable invocation of hockey hustle on the ice: "The legs feed the wolf!" Many Utica hockey and non-hockey fans alike who loved such lines from that film are surprised to learn that the Hall of Famer—and architect of the "Miracle on Ice" men's ice hockey team victory over the indomitable USSR in the 1980 Olympics—coached the Utica Devils during their 1991–1992 season. But to the folks that knew Brooks best, like his daughter Kelly, stints in smaller markets such as Utica were part of Brooks's ultimate goal of sharing his love of the sport to points far and wide. "My father always had a purpose," Kelly recalls, "He wanted to grow the game and have people enjoy the game as much has he did." A three-time NCAA ice hockey champion coach for the University of Minnesota, Brooks was also a longtime coach of the New York Rangers. He returned to the grandeur of Olympic ice to coach the French men's team in 1988 and the American team in 2002 (earning the Silver Medal in the process). The Herb Brooks Foundation, located in Minnesota, continues his work with a comprehensive youth hockey training program that focuses on the Brooks recipe for success: team-oriented play, leadership training, and the joys and innovation to be found in old-fashioned pond hockey. (Courtesy of Kelly Paradise.)

The Utica Devils

Many folks in the Utica area still reflect on their formative hockey-fan days as being shaped by the raucous, deafening, in-your-face experience of seeing the Utica Devils skate in the Memorial Auditorium (also known as "the Aud") in the late 1980s and early 1990s. The Devils were an American Hockey League affiliate of the New Jersey Devils. The overall design of the Aud has been duplicated on much grander scales elsewhere, such as Madison Square Garden, but old-time Devils fans know something that Utica College Hockey fans have learned since they recently made the Aud their home: there may be no better place to watch a hockey game, period. (Author's collection.)

Mark Lemke
Mark Lemke was a star baseball player for Notre Dame High School who went on to play Division I baseball at Purdue University before becoming a professional player in the Atlanta Braves organization. Lemke became a legend among local baseball fans when he was called up to the big leagues in the early 1990s, playing second base for the Braves during their remarkable 1990s baseball dynasty. Lemke played in four World Series, and he and his teammates would win their sole championship in 1995. His fame at home often inspired schoolchildren to affectionately dub their local sandlots "Lemke Field." A fan favorite in Atlanta, Lemke is still active in baseball, doing pregame announcing for the Braves radio network. (Courtesy of Utica *Observer-Dispatch*.)

Carmen Basilio
Welter- and middleweight boxing champion Carmen Basilio (1927–2012) was a Canastota native and hero to a generation of sports fans in Utica during his boxing reign in the 1950s and early 1960s. His career blossomed in local venues like Bennett's Field, and his grassroots, up-by-his-own-bootstraps rise to glory was memorialized in his fighting moniker, "the Upstate Onion Farmer." After serving in the US Marine Corps, Basilio turned to boxing full time. He is probably best remembered for earning the middleweight championship from another boxing legend—Sugar Ray Robinson—at Yankee Stadium in 1957. His influence helped establish the International Boxing Hall of Fame in Canastota, of which he was an inaugural member alongside names like Ali and Marciano. His legendary trainer Angelo Dundee once told the *Boston Globe*, "There was no one with more determination than Carmen," and hall of fame curator Ed Brophy told *ESPN Magazine* upon Basilio's death, "If you were picking someone to carry inside you, to help you keep up the fight, you couldn't ask for a better spirit than Carmen Basilio." Basilio spent his postfighting years throughout the region in the physical education department at LeMoyne College in Syracuse, as a pitchman for Rochester's Genesee Beer, and as a keynote speaker. (Courtesy of Claudia Dugan.)

Robert Cimbalo

The challenges of an artist are myriad, and maintaining relevance is perhaps greatest among them. The fact that Robert Cimbalo's painting *The Victory* (inspired by the events of September 11, 2001), which he produced in his sixth decade as a painter and sketch artist, hangs in firehouses and police stations across the nation is proof enough that Cimbalo continues to be an American artist that matters. It was a separate issue of relevance—that of the fading urban ethnic culture of Cimbalo's youth—that inspired Cimbalo and the themes in his art as an adult. Many of his early paintings capture the remembrance of a East Utica past, the one of his upbringing during the 1940s and 1950s, preserving the values and communal joy of his Italian American neighborhood. Cimbalo suggests that a great deal of the subtext of his work reflects lessons he learned as a child. "There is often so much going on in one of my sketches or paintings because I learned a certain practicality in my upbringing that says everything has a purpose, anything can be used in endless ways." Hence, Cimbalo has conveyed in domestic and public scenes that which he hopes his native Utica will not lose: its ethnic diversity. Cimbalo studied Italian masters in Italy during the 1950s and was a colleague of Giorgio De Chirico, attended the Pratt Institute, and founded the graphic arts departments at Munson-Williams-Proctor School of Art and Utica College (where he began teaching in 1980). He still lives in Utica, where he continues to work on solo and collaborative projects. (All, courtesy of Robert Cimbalo.)

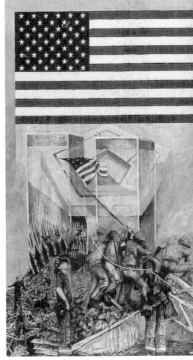

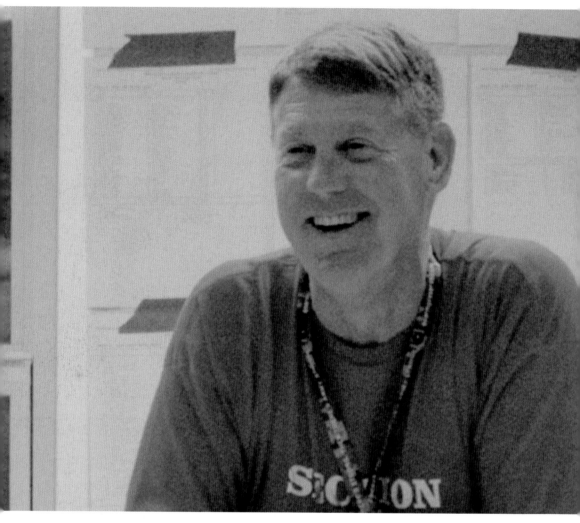

Tom Wells

Tom Wells is a legendary swimming and track-and-field coach who began as a three-sport athlete (football, baseball, and basketball) under then little-known coach Don Edick at New Hartford High. From there, he went on to play football at Springfield College in the early 1960s and was part of an undefeated team in 1965. A physical education teacher at his alma mater for most of his career until his retirement in 2002, Wells has coached New Hartford Spartan boys track-and-field since 1970 and girls swimming since 1986. He is one of the most victorious coaches in Greater Utica history, with a combined-sports record of 731 wins and 232 losses. His boys track team won the athletic section five times, and his girls swim team won sectionals in 1993 and then went on to earn nine straight section titles from 1997 to 2005. Furthermore, his girls swim team has earned Class B New York State Championships 10 times. Recipient of numerous regional and state coaching awards, including induction into the Greater Utica Sports Hall of Fame in 2012, Wells has served the region as Athletic Section III Boys Track and Field chairman since 1980 and has coached the Empire State Games Central Division swim team since 1995. (Courtesy of Tom Wells.)

Classified

With its members' combined musical credentials amounting to what looked like a classified advertisement (hence the name), Classified was the premier live band in the Greater Utica area from the early 1990s until its retirement on New Year's Eve 2012. The above photograph was taken at the band's rehearsal hall at the Moore's Tire Warehouse Garage on Broad Street and shows the original lineup, which included, from left to right, Scott Rutledge, trumpet, flugelhorn, and vocals; Pat Putrello, trumpet, flugelhorn, and vocals; Darryl Sleszynski, saxophone; Johnny Piazza, trumpet; Freddie Faccioli (seated), Hammond organ and vocals; Freddie Zimmerman, trombone and vocals; Larry Desiato, drums and vocals; Danny Brisson, guitar and blue-eyed–soul vocals; Greeley Ford, bass and vocals; and Dave "Dinger" Wingfield, guitar. The band was founded by Faccioli, who, as bandleader Greeley Ford explains, "thought of it, put it together and launched the band just like Maurice White did for Earth, Wind, and Fire." Classified in fact shared the stage with Earth, Wind, and Fire as well as other major touring acts, such as Eddie Money, KC and the Sunshine Band, and the Commodores. (Courtesy of Greeley Ty Ford.)

Will Smith

Will Smith is a two-time National Football League All-Pro player and a Super Bowl champion with the New Orleans Saints in 2010. His football-playing days began at Utica's Proctor High School, where he earned All-American honors and was twice named the Mohawk Valley Player of the Year under coach Guy Puleo. Growing up, he admired NFL Hall of Famer and San Francisco Forty-Niner Jerry Rice, and along with millions of Upstate New Yorkers, he cheered on Buffalo Bill defensive end Bruce Smith. "Watching the Buffalo Bills growing up, you knew you wanted to play like Bruce Smith," Will recalls. Unlike fellow fans, however, he would get to emulate his hero at the highest levels. A defensive standout at the Ohio State University, he helped Ohio to a NCAA championship in 2002. Smith was the 18th overall pick in the 2004 NFL draft and has led the Saints in overall quarterback sacks since 2005. "Utica is a hard-nosed city that taught me how to be disciplined and what it takes to be a better person," Smith says of the town he occasionally gets to come back to on behalf of his nonprofit organization, Where There is a Will There is a Way. Smith says that when student athletes are not on the field with coaches, "there aren't many organizations that can help students learn to become a better football player, to learn how to use football as a vehicle to go where you want to go in life and seek out scholarships." The organization sponsors several educational events for area high school football players, counseling them in the college admissions process, hosting guest speakers, and sponsoring an all-star team banquet with the help of the *Observer-Dispatch*'s Ron Moshier. (Photograph by Charles Illane, Flaumbeux Media.)

The Grove Family and the Bagel Grove
Located on the busy corner of the Memorial Parkway and Burrstone Road, the Bagel Grove has been a favorite Utica eatery since it was founded by Ed (pictured above with children Matt and Nancy) and Carole Grove in 1988. Ed worked as an engineer at General Electric until he and his wife were drawn to the lifestyle of owning and operating a family business. The Groves' son Matt now owns the bakery with his wife, Annie, and has discovered several positive aspects of running the family business beyond serving up fresh and natural baked goods. Matt Grove appreciates "being able to connect and support so many different efforts for positive change, more than if I was just an individual," donating baked goods to local fundraisers such as Relay for Life or community groups like the Rescue Mission, "and similarly being able to connect to the local food movement." For Matt Grove, owning a business in Utica allows him to determine his own rightful balance between profit margins and community involvement since "the lower cost of doing business [compared to major US cities] means we don't have to spend all of our energy just trying to stay afloat." (Courtesy of Matt Grove.)

Symeon's Greek Restaurant

Symeon Tsoupelis arrived in the United States from Xanthi, Greece, with $47 in his pocket and an American dream firmly rooted in his mind. Working at a restaurant in Montreal, Canada, Symeon met his wife, Ann, a teacher from the Utica area. When the two married, they became committed to introducing Symeon's now-signature Greek cuisine to the Utica area. Tsoupelis offered patrons of the Court View Luncheonette on downtown Utica's Elizabeth Street the occasional Greek dish during his short proprietorship there in 1971, and he and Ann opened their own exclusively Greek restaurant on Oneida Street in 1973. Their success mandated more spacious confines, so the Tsoupelis family moved, first to the village of New Hartford and then to Symeon's current location on Commercial Drive in Yorkville. Symeon and Ann Tsoupelis believed "the harder you work, the luckier you get," an ethos that guides their son Symeon Tsoupelis Jr. (pictured here beside a portrait of his mother) in his management of the restaurant today as it enters its 40th year of business in 2013. Symeon Jr. sees an important Old World–New World role for himself at the restaurant. "We want to provide our patrons with the flavor of Greece . . . but also remind people how great it is to live here. People that live in the Mohawk Valley need to be its biggest cheerleaders." (Photograph by J. Davis.)

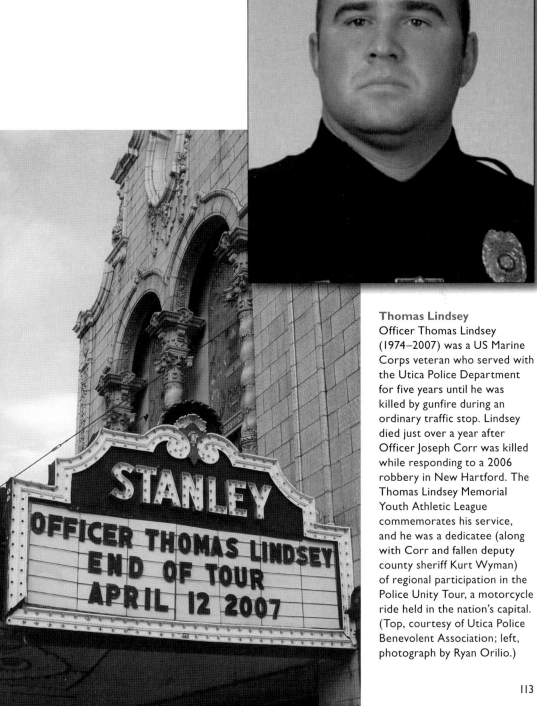

Thomas Lindsey
Officer Thomas Lindsey (1974–2007) was a US Marine Corps veteran who served with the Utica Police Department for five years until he was killed by gunfire during an ordinary traffic stop. Lindsey died just over a year after Officer Joseph Corr was killed while responding to a 2006 robbery in New Hartford. The Thomas Lindsey Memorial Youth Athletic League commemorates his service, and he was a dedicatee (along with Corr and fallen deputy county sheriff Kurt Wyman) of regional participation in the Police Unity Tour, a motorcycle ride held in the nation's capital. (Top, courtesy of Utica Police Benevolent Association; left, photograph by Ryan Orilio.)

Joseph Corr

It is often said that it is not until tragedy strikes that people cease taking for granted the sacrifices that public servants make to maintain the fabric of a community. Joseph Corr died in the line of duty in February 2006 at the mere age of 30 while attempting to apprehend one of several suspected jewel thieves leaving the scene of a crime on Commercial Drive in New Hartford. Upon his death, the entire region rallied to honor his service and to support the Corr family. Hundreds of police officers marched in his funeral procession down Oxford Road to St. John the Evangelist Church. Public displays honoring Officer Corr include the Joseph D. Corr Memorial Highway (a section of Route 840), New Hartford High School's Corr Field (in recognition of his years as a varsity baseball standout), memorial scholarships at New Hartford High School and Herkimer Community College, and a charity softball game organized by Corr's loved ones. (Left, courtesy of the Corr family; below, photograph by J. Davis.)

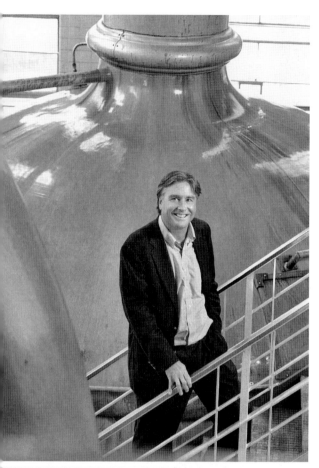

Fred Matt

Fred Matt currently serves as brewery president and chief operating officer at the Matt Brewing Company. The son of F.X. Matt II, he has focused his managerial efforts on the expansion and distribution of the Saranac family of beers. In addition, Matt helps in the joint effort between the brewery and the United Way in hosting "Saranac Thursdays," a weekly event during the summertime that brings thousands of locals and tourists to the brewery district each Thursday evening for beer, live music, and community fundraising. (Photograph by Nancy Ford.)

Bernard Gigliotti

Gigliotti's Driving School has prepared countless drivers for the big day. Bernard Gigliotti, pictured below during the mid-1970s, took over his father's business in the Oneida Square neighborhood, where students still attend driving–preparation classes to this day. Bernard's son Bernie has, over the last 15 years, established several satellite classrooms throughout the suburbs. (Courtesy of Gigliotti's Driving School.)

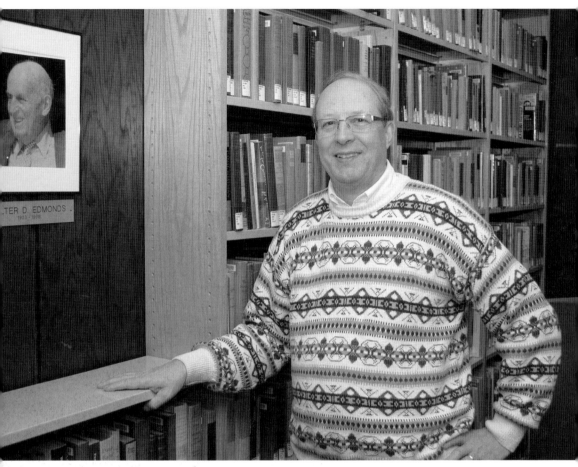

Prof. Frank Bergmann

Frank Bergmann will devote much of his years as professor emeritus at Utica College to studying the college's Walter Edmunds Collection, a scholarly treasure trove that Bergmann helped secure from the *Drums Along the Mohawk* author himself. His role as curator caps an academic career as Utica College's longest-serving tenured professor. He taught literature and languages beginning in 1969 and also fulfilled several administrative roles, including associate dean for the humanities, associate dean for arts and sciences, and director of the Nassar Ethnic Heritage Studies Center from 2004 to 2012. Bergmann was born in Nazi-era Germany, and his family also lived under the gaze of Josef Stalin as postwar East Germans until moving to West Germany in the mid-1950s, the Berlin Wall quickly rising behind them. Fittingly, Bergmann had evaded one of the 20th century's greatest hurdles to become a celebrated scholar who inspired students to challenge the barriers to their own understanding of complex texts. As one student recalls, "[Bergmann] taught us to be hard on ourselves when we needed to be, and not to be afraid to be the only one wiling to work hard for something . . . [he] taught us to look deeper, beyond the simple words on a page for a meaning that not every person would find." (Photograph by J.P. Bottini.)

State Senator James Donovan

James Donovan (1923–1990) was a New York state senator whose political leadership extended across New York, chiefly as a champion of innovation in education, environmental stewardship, and progressive health care reform for mental illness. A product of the Great Depression and a US Marine during World War II, Donovan spent the greater part of his adult life in leadership roles at the local and state level, basing many of his policy decisions on his formative years spent first on the Marcy, New York, farm his family eventually lost during the Depression and later in the West Utica neighborhoods. His son Jerry, himself involved in political affairs in the Greater Utica area, recalls that his father's wartime service and "his family's strong Catholic faith and the experience of moving to West Utica as a youth with its exposure to different nationalities all play a role in what shaped him as a leader. He grew up with and witnessed the values of sacrifice, hard work, determination, respect for others, charity, honesty, honor and duty." The *New York Times* remembered Senator Donovan in a 1990 obituary as instrumental in the creation of the New York City School Construction Authority, one of his many accomplishments as chair of the Senate Education Committee. Though widely respected, Donovan was often at odds with his downstate colleagues, mainly for his conviction in protecting local-municipality water rights and promoting environmental preservation. Closer to home, Donovan is still remembered for the key role he played in numerous economic and educational initiatives, such as championing a permanent campus for the State University of New York Institute of Technology in Marcy. A middle school, baseball stadium, and an academic hall at the SUNYIT campus are all named in his honor. Then state majority leader Ralph Marino told the *New York Times* upon Donovan's passing that "Jim Donovan's most lasting contribution will be in the field of education, where he assured that quality and affordable education was this state's top priority." (Courtesy of Jerry Donovan.)

Rev. Paul Drobin

Rev. Paul Drobin's prescription for the future of the Utica area is simple: "All we need is less Exodus and more Genesis." Galvanized by the political and social upheavals of the 1960s while a student at Theological College in Washington, DC, Reverend Drobin came home to the Utica area motivated by the examples of President Kennedy and Dr. Martin Luther King Jr. as well as the reform efforts of the Second Vatican Council. A high school religion teacher in Rome and Utica during the late 1960s and early 1970s, he served as chaplain of Hamilton College from 1973 to 1980 in addition to fulfilling leadership roles at Catholic Charities in Utica throughout the 1980s. An inspiration to countless worshippers of diverse faiths while at St. John the Evangelist Church in New Hartford from 1987 to 1999, Reverend Drobin has served the last 14 years as chaplain at Utica College and SUNYIT. (Courtesy of Reverend Drobin.)

Leo Gilman

"You can say that a barber has 20,000 friends," Leo Gilman suggests while cutting hair at Utica's Union Station Barber Shop, a recent venture that he took up after barber Dan Greaco's 67-year career at Union Station. Gilman is humble about the personal relationships that he has established in his nearly 41 years of business because he knows that "in barbering you get to hear the best and the worst that people have to tell, and over the years you form a pretty personal relationship." Customers can still on occasion catch Gilman at his original home, cutting hair in the first chair at the New Hartford Barber Shop on Campion Road. (Photography by J. Davis.)

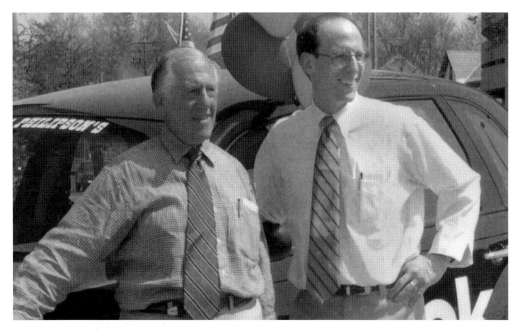

Gary, Herb, and "Uncle Louie" Philipson

Philipson's Army and Navy store has been a Greater Utica retailer for decades, beginning as a family-run sporting-goods outfitter in downtown Utica and later expanding to a chain of retail stores as initiated by Herbert J. "Herb" Philipson (above, left) with the addition of a Rome store in 1951. Herb worked for his uncle Jack Philipson at the original Utica store alongside his father, "Uncle Louie" Philipson (pictured below, left). A local celebrity in his own rite, Uncle Louie was a natural television pitchman for the store with his years of experience as a Vaudeville stage performer. "My father (Herb) had very little money, but he worked hard, was smart and was honest and fair," Gary Philipson (above, right) recalls. Herb starred in a long-running series of commercials in which he posed as a boxer taking on the competition as a character known as the Price Fighter, whose likeness still appears in advertisements today. (Both, courtesy of Gary Philipson.)

Albert Circelli

Albert Circelli, a World War II and Korean War veteran from East Utica, prepared the table used for the signing of the Japanese surrender from World War II on September 2, 1945, on the USS *Missouri*. He is one of the many servicemen photographed at the treaty signing. Circelli says of today's servicemen and women, "They are great kids. They are as good as we were. If they were in the same position we were in, they would be known as the Greatest Generation." In this image, Circelli is the sailor on the far left, hand in front of his knee, looking out to sea. (Courtesy of Albert Circelli.)

Johnny Scarfo

A mild-mannered pastry chef for years, Johnny Scarfo is one of only four Marines still alive today of a platoon that launched arguably the most famous, and certainly most iconic, assaults of World War II: the Battle of Iwo Jima. Scarfo told the *Life and Times of Utica* in 2002, "I thought the war was over when we took the hill," referring to the now famous raising of the US flag on Mount Suribachi; the war would last five more months. (Courtesy of Johnny Scarfo.)

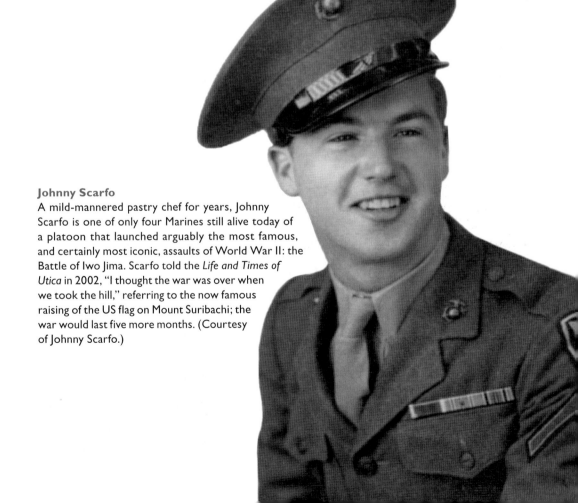

Anthony Schepsis
It is said that Anthony Schepsis (1918–1987) was perhaps most proud of the fact that he was the only principal of Utica Free Academy to have actually also been a graduate of the school. Others, however, would argue that his 20-year administration of the school was only one role of a multidimensional leader. An honors graduate from Hamilton College, Schepsis was chief of Intelligence Operations during the occupation of Berlin after World War II (retiring as a colonel in the Army reserves), and a translator at the Nuremburg Trials. Multilingual and a noted string instrumentalist, Schepsis devoted himself to countless community organizations, including the Boy Scouts of America, the YMCA, and Utica Symphony Orchestra, and he is remembered as a trusted leader and a much-emulated Renaissance man. (Courtesy of the Schepsis family.)

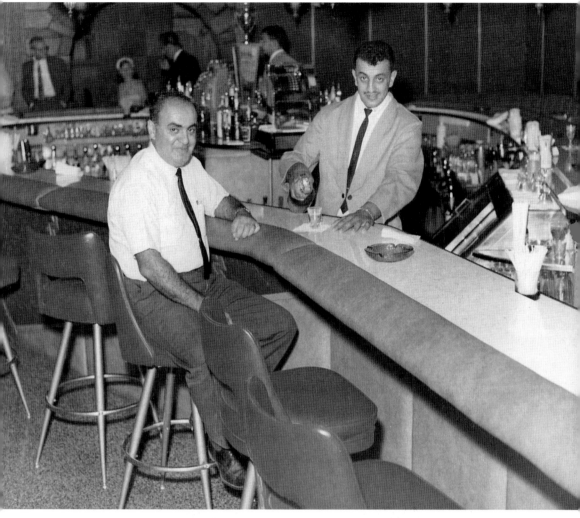

The Massoud Brothers

Legendary Massoud's Oud Lounge earned its name after its distinctive centerpiece bar, where patrons gathered around a replica of an oud, a classical Middle Eastern guitar drawn and constructed to scale (though 30 times larger). The famous bar, along with the restaurant it called home, was designed to honor the Lebanese family heritage of veritable Renaissance man Anthony "Omar" Massoud (pictured pouring drinks at the bar), an architect, civil engineer, and military policeman turned restaurateur, who planned to convert the site of the former White's Inn into a larger establishment with the help of his elder brothers John (seated), George, and Joe beginning in December 1960. A family-run establishment, it grew from a pub offering drinks and fish-fry dinners to a reception hall capable of hosting more than 700 guests. Massoud's closed its doors on New Year's Eve 1986, by which time John Massoud estimates that "the restaurant," as it was known to the Massoud family, had hosted nearly 2,000 receptions, including weddings, business conventions, and retirement parties, with New York governors Malcolm Wilson, Nelson Rockefeller, and Mario Cuomo among the attendees. The Massoud family established yet another business—Massoud's Tree Farm—where families have selected their holiday decorations for nearly 30 years. (Courtesy of Judy Massoud.)

George Frattasio and Judy Gorea's Georgio's Village Café

Georgio's Village Café first opened in New Hartford in 1996 and has had a devoted following ever since. As Judy Gorea explains, "Anyone who comes to dine at Georgio's really becomes our friends and family." Georgio's is the shared vision of Gorea and her cousin George Frattasio, a chef who experiments with his own take on Italian American cuisine and features, perhaps, the region's favorite style of "East Utica Greens" (a popular Italian folk dish of escarole, garlic, prosciutto, and hot peppers). Not an evening goes by that Georgio's is not packed with patrons, and it remains a popular destination for former Greater Uticans during visits home. The café moved into more-intimate confines in February 2013 just a few doors down from its original Genesee Street location in the heart of New Hartford. (Courtesy of Georgio's Village Café.)

Joseph P. Bottini

"It is not your *aptitude*, but your *attitude*, that determines your *altitude*." Students decades hence will be able to recite maxims such as this, one of the many Joseph P. Bottini instilled during nearly four decades in education. Bottini gave his cherished "Bottinisms" and his American history lessons equal weight, because there was little point in teaching the history of an inspiring nation if he did not motivate children to become inspiring people. "A teacher who does not teach a moral lesson," Bottini argues, "is little more than a walking encyclopedia." Drawing from his own struggles as a high school student, family tragedy, a deep relationship with God, and years in the military, Bottini has turned his experiences into discussions that have left an indelible mark on his audiences. The subject of numerous articles in the *Observer-Dispatch*, Bottini has spent the past decade writing his own periodic column focusing on educational issues. His pictorial survey of the city he loves, Then & Now: Utica, sparked a new degree of interest that encouraged many local history buffs and authors to more closely examine the history of the Mohawk Valley region. Bottini earned local, state, and national accolades for his teaching at Kemble School in Utica and Perry Junior High in New Hartford, where he retired in 1999. He continues to teach local history classes at Mohawk Valley Community College, yet it is local policy makers—assembly members, senators, the New York commissioner of education, and his fellow board of education members at Sauquoit Valley Central School—who are reminded that when "Joe Bo" is around, class is always in session, and everyone's input is important because "one cannot teach in a vacuum." (Courtesy of J.P. Bottini.)

BIBLIOGRAPHY

Bean, Philip, and Eugene Paul Nassar (with Angela Elefante). *Rufie: A Political Scrapbook.* Syracuse, NY: Ethnic Heritage Studies Center of Utica College, 2009.

Clarke, T. Wood. *Utica: For a Century and a Half.* Utica, NY: Widtman Press, 1952.

Crawford, James. "The Sculpture of Henry DiSpirito." *American Art Review,* XIII, 3, 2001: 180–181,192.

Cullen, Jim. *Imperfect Presidents: Tales of Misadventure and Triumph.* New York: Fall River Press, 2010.

Ellis, David Maldwyn, and Douglas M. Preston. *The Upper Mohawk Country: An Illustrated History of Greater Utica.* Woodland Hills, CA: Windsor Publications, 1982.

Glatthaar, Joseph T., and James Kirby Martin. *Forgotten Allies: The Oneida Indians and the American Revolution.* New York: Hill and Wang, 2006.

Hatfield, Mark O. *Vice Presidents of the United Statesz: 1789–1993.* Washington, DC: US Government Printing Office, 1997.

Mazloom. A. "Triumphs and Tragedy of Computer Visionary George Cogar." *Mohawk Valley History* 3, 1, 2007: 84–99.

MacFarquhar, Larissa. "The Pollster." *The New Yorker.* October 18, 2007.

McGuire, James K, ed. *The Democratic Party of the State of New York.* New York: United State History Company, 1905.

Nassar, Eugene Paul. *Local Sketches.* Syracuse, NY: Ethnic Heritage Studies Center at Utica College of Syracuse University, 2003.

Oldenburg, Ann, and Gary Levin. "Curtain Falls on Dick Clark, but Not on His Legacy." *USA Today,* April 18, 2012.

Ogle, Maureen. *Ambitious Brew: The Story of American Beer.* New York: Harcourt Press, 2006.

Perlman, Bennard B. *The Lives, Loves, and Art of Arthur B. Davies.* Albany, NY: State University of New York Press, 1998.

The History of Oneida County. New York: C.L. Huston Co., Inc., 1977.

Thomas, Alexander R. *In Gotham's Shadow.* Albany, NY: State University of New York Press, 2003.

Tomaino, Frank. *History Just for the Fun of It: Sketches of Utica's Glorious Past.* Utica, NY: Good Times Publishing, 1998.

Tryphonopoulos, Demetres P. *The Celestial Tradition: A Study of Ezra Pound's "The Cantos".* Ontario, Canada: Wilfred Laurier University Press, 1992.

Walsh, John J. *Vignettes of Old Utica.* Utica, NY: Dodge Graphic Press, 1982.

INDEX